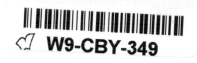

WATERCOLOR
From the Heart

Watercolor From

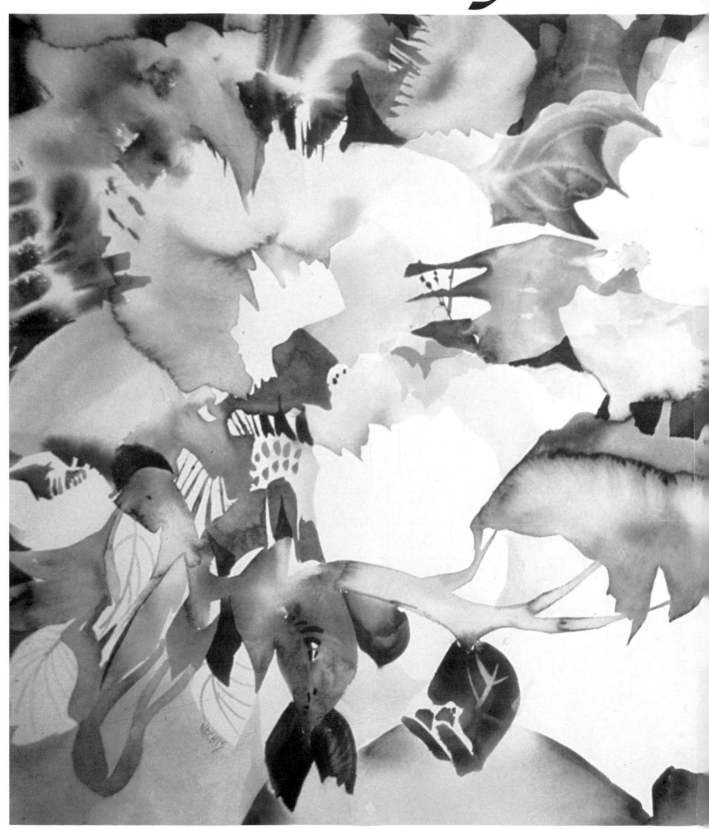

the Heart

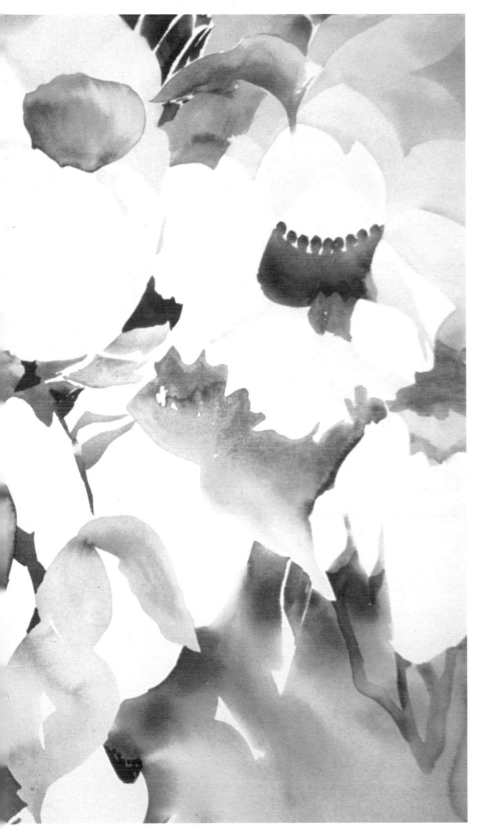

TECHNIQUES FOR PAINTING THE ESSENCE OF NATURE

Barbara Nechis

WATSON-GUPTILL
PUBLICATIONS
New York

To Andrew, who gives me love and space; my children, who have become my dearest friends; my mother, who is an inspiring example of boundless energy and youthful spirit that belies her ninety years; and to the memory of my father.

Cover:
ANOTHER CHRYSALIS?
30 x22" (76.2 x 55.9 cm).
Collection of the artist.

Title page:
CHORUS
22 x 30" (55.9 x 76.2 cm).
Courtesy of F. Dorian Gallery,
San Francisco, California.

Copyright © 1993 by Barbara Nechis
First published in 1993 in the United States by Watson-Guptill Publications, a division of BPI Communications, Inc.
1515 Broadway, New York, New York 10036

Library of Congress Cataloging-in-Publication Data
Nechis, Barbara.
 Watercolor from the heart : techniques for painting the essence of nature / Barbara Nechis.
 p. cm.
 Includes bibliographical references and index.
 ISBN 0-8230-1624-2 : $29.95
 1. Landscape painting—Technique. 2. Watercolor painting—Technique. I. Title.
ND2240.N43 1993
751.4'2—dc20 93-16015
 CIP

Permission to quote from *Tao Teh Ching* by Lao-tzu, translated by John C. H. Wu: Copyright ©1961 by St. Johns University Press, New York. Reprinted by arrangement with Shambhala Publications, Inc., 300 Massachusetts Ave., Boston, MA 02115.

First printing, 1993
Manufactured in Italy

1 2 3 4 5 6 7 8 9 / 00 99 98 97 96 95 94 93

CONTENTS

PREFACE

After writing my first book, *Watercolor: The Creative Experience,* the practice of writing became a habit for me, and I found myself jotting down new thoughts, collecting quotes, and making memos of ideas that I had communicated to my students. Although I suspected that these would eventually become another book, this was not yet a goal. It took a catalyst to produce my commitment to turning these notes into a book.

The catalyst came when I was spending an afternoon with relatives. One of them was sitting with her daughter of around six years old, who was coloring in a coloring book. The mother chastised her for coloring outside the printed outlines. That comment affected me deeply because my life is about creativity and here the daughter's creativity was being potentially stifled. I returned home to write what would be the first page of this book. The computer diskette containing my manuscript is nicknamed ITSOK, meaning: It's Okay to Go out of the Lines!

Since the first book, I have built two studios, my children have grown up, I have moved 3,000 miles from my roots, and I have taught countless students in workshops from coast to coast. My experiences in painting and living have produced changes in both my thought and work.

I think of teaching as a chain and myself as one of its links. I am grateful to the many fine teachers I have had, especially my friends, who have by example given me much to think about concerning what good teaching is. My idea of good teaching is that it does not always provide answers, but must always provoke questions. I selected the quotations I have used in this book in the hope that these viewpoints will contribute to the methods and ideas of other teachers, who will, in their turn, add to them and pass them on to their own students.

Classes and books are often categorized as to level. When I last taught a beginner's class, I felt that my teaching suffered from the categorization: By simplifying material, I was limiting the information I was giving. On the third day, I proclaimed my class to be intermediate, and things went better for everyone after that. Students benefit from each other's ideas and are challenged by those farther along in the process—though at times it may seem to the student like being thrown into deep water and expected to swim.

I did not write this book for beginners, so now I decree that those of you who were beginners are no longer. I am grateful to my publisher for its belief that there is need for material for advanced students and teachers as well as beginners. This has given me the opportunity to express what I so strongly believe in.

I am deeply grateful to Andrew D'Anneo, my husband, "in-house" editor, and chef, for relentlessly sending me back to the word-processor when my text lacked clarity and for saving me from fast food and mediocre wine when deadlines were imminent. I am indebted to Candace Raney, Senior Editor, for making an intense period of hard work a pleasure, because every suggestion showed intelligence and sensitivity. Dale Ramsey's skillful editing continued the process, especially in choosing headings from my text that had eluded me. Jay Anning's superb design made it come together beautifully. To the others at Watson-Guptill whom I have not met, thanks are due for the teamwork that has brought this book to fruition. The content has been enhanced by the generosity of the artists, museums, and collectors who have provided work. Many friends have contributed by sharing anecdotes, ideas, quotations, and favorite places to explore. I am particularly thankful to Gary Freeburg for bringing to me a new awareness of what constitutes fine teaching and, in the process, providing unforgettable experiences of Alaska. Stephen Szabo of Trillium Workshops took the time to introduce me to places I would not have found.

Marylyn Dintenfass, with her impeccable standards, has always been there to provide challenges and help me fine-tune. Richard Jansen's outstanding designs for my studios continue to inspire as well as to give me something to live up to. Diane Faxon and Frank Webb, inspired teachers as well as fine painters, continue to encourage me. Jerry Cohen, Julie Lawrence, Fran Greenfield, Bea Marlais, Julia Jordan, Jacqie and Bob Langdon, Jerrine Grim, Joanna and Mark Friedman, Alex and Barry Nechis, Sharon and Robert Castillo, and many D'Anneos all contributed by listening, encouraging, making suggestions, providing support, and enriching my life.

Writing this book has been fulfilling for me, and I leave it with both relief and regret. Although I have not covered all I intended, I now abandon it to you, the reader, because I am a painter, not a writer. Just as I very selectively choose what to paint, I have selectively explored a very personal area of interest to me.

KAUAI BEFORE
15 x 22" (38.1 x 55.9 cm). Collection of the artist.

INTRODUCTION

I dream and my soul awakens.
Imagination is the star.

—CARL JUNG

Like a child with a coloring book, I have often gone "out of the lines," both on paper and in my own life. This book is for those who have likewise done so, and it is especially for those who have never done so and would like encouragement or permission. It is also about how I make a picture, how I choose or am chosen by the many influences around me, particularly those in nature.

Perhaps my experiences and methods will spark in you a new appreciation of how to use your unique self and your own influences to create pictures—and will enable you to gain a new awareness of the achievements of others.

I cannot teach you how to paint a tree or a mountain or a flower, because there are many kinds of these and many ways of painting each. I hope I can help you to become your own teacher and to find your own way. I can tell you that there are no perfect colors, no foolproof methods, no surefire ways to win awards or sell paintings, no magic brushes and, most disheartening of all, no formula for creating the perfect painting. I attempt to create something that pleases me in each of my paintings. The colors, methods, and forms are suggested by what the painting seems to need or wants to be.

We can all learn to see better, to paint what we already know even when we fear that we don't, to follow our hearts, and to discard formula and enjoy the creative process.

When I ask new students why they have selected my course, a significant number of them indicate that they want to "loosen up." Many have become bored with their work and with the restraints of exercises, rules, and routine. A smaller number come for a different reason: They want to add structure to their experimental work so that results will be due to competence rather than luck. Both groups find value in broadening their scope to include both approaches. Personal psychology should be the deciding factor as to which way of working should dominate for you.

My niche is not a compromise between the two practices. In my work I wholeheartedly embrace the balancing of control with flexibility in my thought process. To me this is an unbeatable combination that creates a sense of freedom while allowing the control that I need to make paintings with my own personal stamp. The breadth of my work comes from the directions I choose to follow, combined with the contributions made by water and paint when they are encouraged to do what they do best.

I concur with John Marin's evaluation of structure: it is the backbone of a good picture, and without structure (in the mind's eye) there can be no real creation.

My early paintings were the result of efforts to learn technique by imitating the strokes of my teachers and copying the landscape, flower, figure, or photograph in front of me. When the method of reproducing these objects became habitual, the challenge was gone. I began to experiment because I was bored. As soon as I became a beginner again, leaving behind the safe design patterns of others and seeking new ones, my interest returned. The successes became less frequent, but more satisfying.

My struggle to depart from my mentors taught me infinitely more than my imitative efforts. In the final analysis, if my work is to be remembered, it will be because it differed enough from others' to be recognized as mine, not because it resembled that of a teacher. I have precious memories of a time when I formed a dedication to art in my life and discovered my own way. This time was a greater gift to me than the techniques and formulas that I have long ago discarded.

INNER RESOURCES:
THE CREATIVE
PROCESS

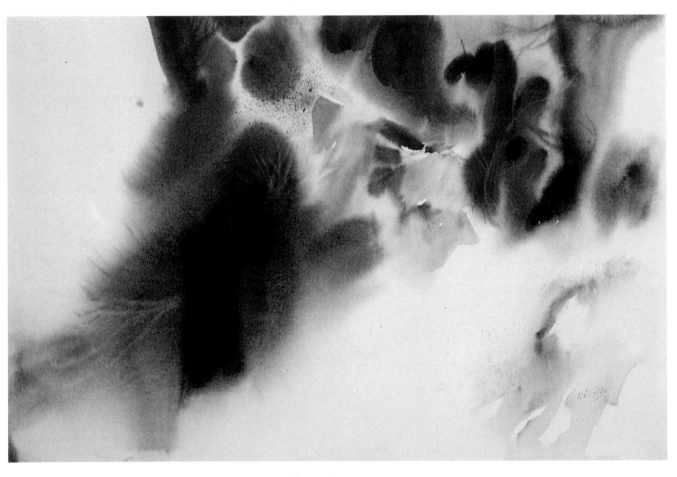

IN THE WOODS
15 x 22" (38.1 x 55.9 cm). Collection of the artist.

I WASTED SO MUCH TIME in my youth trying to force the round peg of my self into square holes that I am wary of any teaching that allows no room for individuality and personal choice. Critical analysis of the learning process has helped me find a better path. ❦ I was once convinced that I had no aptitude for a foreign language. In order to save face in the classroom, I had had to concentrate on memorizing, rather than on understanding the theory needed to construct my own sentences. After years of feeling insecure in classes, I discovered an innovative language-tape system that helped me to assimilate information through interesting instruction rather than through the sorts of memorization and rote exercises that plague students in many fields. ❦ A beginning student came to my weekly classes when the lessons were subject-oriented; she reported that a friend who was taking a series elsewhere was surprised that my class was painting pictures while her group was practicing graded-wash and colored-swatch exercises. By the end of the semester, both students could run competent washes, one because of practice, the other by painting skies, fields of snow, sand dunes, and other subjects that employ washes. My student was completely involved in composing pictures, and she became proficient at washes without being aware of it. By exercising design and technical skills together, rather than in linear order, she did not neglect mind work while cementing technique, and she progressed faster. ❦ Some students are technically skilled and render their subjects with great competency, yet they have such poor perception of their ability that they continue to study with teachers they have surpassed in thought, if not in technique. Technique, rather than the creative thought process, tends to dominate teaching so heavily that some students who have not yet begun to analyze, change, and grow are bewildered when they finally attain competency but do not see their work being accepted for exhibits. Many can recite design rules and employ them quite well, but they do not go on to say something of lasting value. To paraphrase the pianist Vladimir Horowitz: "They play the notes correctly, but when will they begin to make music?"

> *You can save time if someone tells you to put blue and yellow together to make green, but the essence of painting is a self-disciplined activity that you have to learn by yourself.*
>
> *—ROMARE BEARDON*

1 DEVELOPING INDEPENDENCE

Students too often tend to accept uncritically what their teachers present and consequently never learn to evaluate information for themselves. To be self-taught is to assimilate knowledge and to rely upon oneself to decide what to store, adapt, and use. The greater the concern with capturing someone else's technique, the more difficult it is to find one's own way. Some of the steps that we swallow whole while learning to become artists are arguably necessary, but they can prove to be stumbling blocks.

At first, it is natural to concentrate on formulas for color, design, and so on—these are our technical alphabet, the mastery of which helps us to become more confident. When I was a young, inept painter, I heard the word "slick" applied pejoratively to the work of some of my acquaintances. It connoted commercialism and a lack of art spirit. But it did connote competence, too. My work at that time was so incompetent that I longed to be slick. Eventually, I realized that although technical competence is essential, it is imagination, intuition, and the study of fine art that are crucial to producing work that is not merely mechanical or stylized.

My authentic development as an artist began at the Museum of Modern Art, in New York City. I saw Picassos, I saw works by Rothko and Matisse. I knew that I was supposed to like the work; it was famous. But I was uneasy. I didn't understand it, and I thought I was supposed to. But the more time I spent with seemingly difficult work, the more I liked it. Finally, I began to develop a physical and emotional reaction to particular pieces of original art.

We do not respond to reproductions of art the same way we do to the original work; they can only help to familiarize one with the piece. (The sheer bigness of many works has a great deal to do with their impact.)

Different artists cause different reactions from people. A particular color chord in a Matisse once brought me to tears. The books I have reproducing Rothko's work are only reminders of the feelings I have had when standing in front of a nine-foot shape of undulating, hypnotic paint that seems to envelop me. Marjorie Phillips quoted her husband, Duncan—they were among the nation's most distinguished collectors—as having found in Rothko's work an "enveloping power" that

> conveys to receptive observers a sense of being in the midst of greatness. . . . These canvases which have been called empty by the resistant skeptics and which certainly depict nothing at all are nevertheless a vibrant life-enhancing experience to those who make themselves ready for them. They cast a spell. . . . They not only pervade our consciousness but inspire contemplation.

As I developed, I found that traditional work spelled out too much for me. There were no surprises. I have often loved work by an artist new to me, but later stopped reacting to it because it became too familiar. More appealing and of lasting value to me is work that says new things to me each time I experience it.

Reassessing the Rules

Once I had developed confidence in my independent judgment, it became clear that I could love certain paintings and dislike others that had been proclaimed great. Next, I began to question why even the paintings I loved departed from the design rules I had been taught. For instance, is there any center of interest in Monet's monumental water lily paintings (about which the critic Clement Greenberg wrote that pictorial form broke down into an "all over" web of sensation)? The center of interest in Leonardo's *The Last Supper* virtually celebrates its center, violating another rule. There isn't a single linking light shape in Matisse's *The Red Studio*. And color? Matisse hardly ever repeated it for balance. Did he miss that lesson?

Had I asked my teachers why there was a discrepancy between the design and color rules I had learned and these fine expressions of art, they perhaps could have explained how some of the rules were considered and discarded or

followed in ways that were not obvious to me. Since so much of the work broke the rules I had been taught, I began to think that rules might not be rules after all. Perhaps guidelines? A place from which to depart? Finally I could look at the Grand Canyon and begin to paint without worrying about where to place my center of interest.

Once an art group invited me to judge the work displayed at their annual dinner meeting. Most of the spouses invited had little art education. The popular award was given to a correctly rendered boat in dry-dock. My choice was an unusual and somewhat primitive waterfall. Aware that few understood why I had made that choice, I explained that the waterfall would be the only memorable painting to me, and that has certainly been the case. Not everything we remember is necessarily worth remembering, but whether it is memorable can be a criterion for valuing work, aside from its correctness.

Choosing Your Painting Approach

A fact ignored by all my teachers was that life experiences influence a painter's approach. The bulk of my teachers were men and their students, women. Those of us who became teachers generally had few women as mentors and so continued to teach the way we had been taught, never profiting from an examination of our experiences as women—what we did and why.

I was taught that I should sketch my subject, plan the values, transfer the sketch to my painting surface, and fill in the shapes with paint. Obviously, a painter who can structure painting time so that he or she proceeds from A to Z, with lunch appearing at the appointed hour, water and brushes periodically whisked away to be cleaned, and telephone calls screened, will have a different attitude toward the process than one who must snatch painting periods between preparing meals, doing laundry, car pooling, and the thousand interruptions caused by small children. I am not suggesting that it is more difficult for those who juggle many tasks, only that a continuous procedure may be frustrating for them to follow.

Many painters complete their work in one painting session. Often work done this way is subject-oriented and involves direct painting, in that each area is painted once with the proper color and value. On the other hand, layered paintings more often involve process and discovery and can take some period of time to evolve.

Nowadays very few of my paintings are completed in a single painting session. I do not remember when my transition away from painting directly occurred, but when my children were small, their naps were never long enough to allow me to complete large paintings. So I learned to adapt and soon preferred the layering method, which allowed more time to think about what would be the best way of completing a painting.

I rarely finish any task in a single session, nor do I devote large, uninterrupted blocks of time to painting, although the small blocks add up to substantial amounts of time. My daily routine is both disciplined and not disciplined. Sometimes I have deadlines that must be met, but the order of the tasks that add up to the completed objective is my choice.

Just as some people read several books at a time, I always have many paintings evolving. When my motor coordination is at its peak, I work on those that need fine detail; when I feel analytical, I try to solve problem paintings. I may put several finishing strokes on a few paintings, perhaps a stroke to shake loose a painting in a rut, and when I am feeling exceptionally creative I begin a new one. My discipline is in bringing forward many projects at the same time, and eventually finishing most of them, by tuning into my own moods and performing the most suitable tasks.

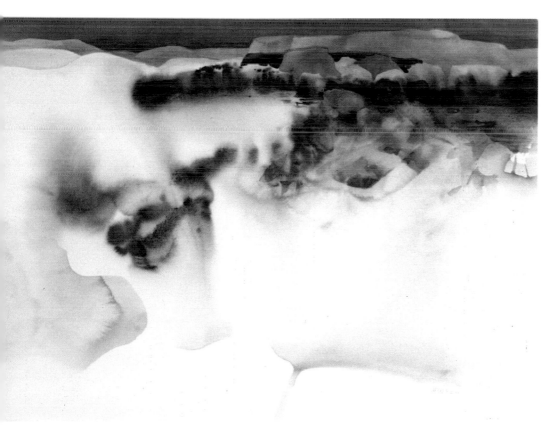

KENAI COAST
*22 x 30" (55.9 x 76.2 cm).
Collection of the artist. Lena
Newcastle Award, American
Watercolor Society, 1985.*

This painting is the result of an extended visit to Alaska. I began by painting on wet paper: first the red "blooms," then the small shapes behind them—even though I did not yet know what the painting would be. I finished the painting many months later by adding layers of red at the top to suggest mountains and sky.

Ideas: A Matter of Process

My objective is to allow my feelings about a subject to come out naturally, then guide them into shapes and value patterns. I try to paint so that the viewer finishes the picture. Although the feeling of trees, mountains, flowers, or water is there because I have used their basic shapes, I haven't actually painted these objects. Each painting is new, and by allowing the water and paint to flow, letting the paper itself suggest the subject matter and the technique as well, ideas begin to arise.

> My paintings never turn out the way I expect them to, but I'm never surprised.
>
> —ANDY WARHOL

Frequently, places I have visited and shapes that I have seen appear as soon as I place a few strokes on a piece of paper. I encourage this to happen naturally; I do not plan or direct it, but I do make use of it. My choice of subject matter and approach to painting reflects my life-style. I travel a great deal and return to the places that produce my greatest reactions to the environment. The city scene I paint will be the result of a lifetime experiencing New York, of a month in Rome, of my new life near San Francisco, or perhaps of some visual memories of Anchorage, Alaska. The result becomes a recognizable mélange: the essence of "city." Similarly, my trees may reflect both pines and palms, and my flowers are a new hybrid of several species. The artist has turned botanist.

MY CITY
15 x 22" (38.1 x 55.9 cm). Collection of the artist.

Note the strangely shaped building in this city mélange. I had no idea where there might be such a building, and then a student volunteered on what street it could be found. Whatever we invent can usually be found.

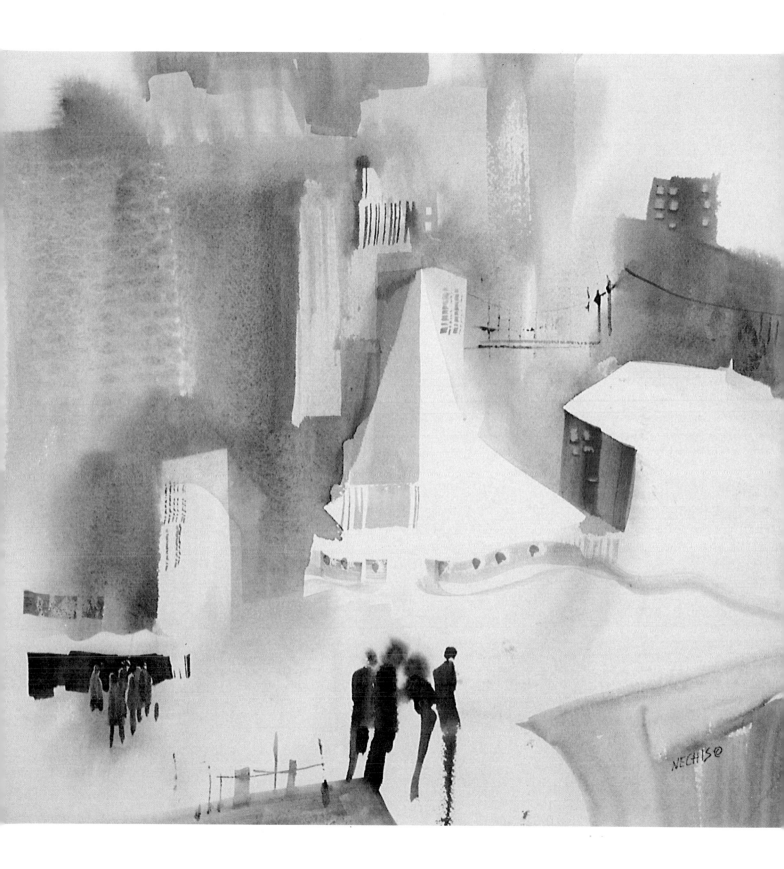

On Your Own and Experimenting

I love to experiment. I am challenged by a new piece of paper. I can't fail because I have no expectations and no preconceived plan. It is more difficult for me to be flexible when I expect a certain outcome.

Blank paper lies before me. I begin. Initially my mind is a *tabula rasa*. No thoughts, only feelings. I pick up a brush. I wet all the paper, part of it, or work it dry. I place a stroke somewhere on my page and make a mark. I like it. I make another. What will happen if I extend this shape to the left? What if I bring it out on the other side? Now I remember that shape. It resembles the water at the base of a quarry. Oh! that light down the middle could be a waterfall. Yes, I like it. It is a bit surreal. This shape looks like a bird. Do I really want one? No, I'll extend the shape to lose the bird. My color is uninteresting. I'll add orange to my waterfall. Now some pink. How about a purple/black rock? Too dark. I'll neutralize the area next to it for less contrast. Now some green moss. I need a softer edge. What else needs fixing? I don't know. I'll come back to it. I go through this process again and again, watching, adding, making changes, thinking.

GENESIS
22 x 30" (55.9 x 76.2 cm). Courtesy of The Artful Eye Gallery, Calistoga, California.

Small flowers appear to spring from the large one. I made the flower centers with spurts of wet paint on wet paper, then let it dry. Next I added glazes for hard edges that would sharpen the image.

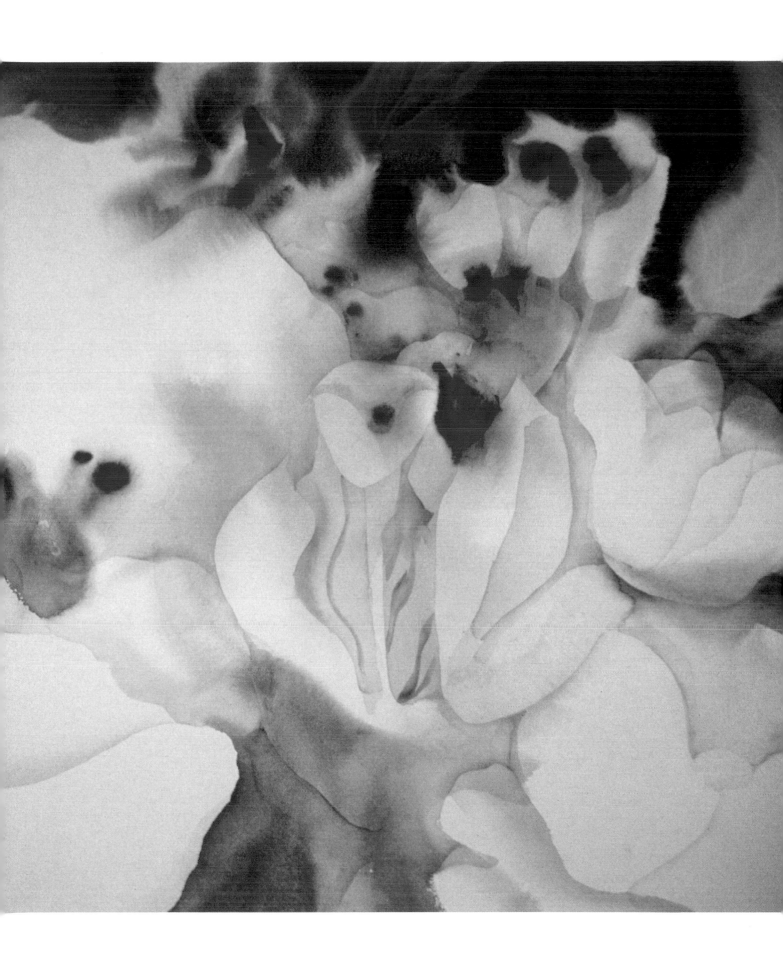

Taking Advantage of Accidents

"Accidents prefer the prepared mind," it has been said. "Luck happens," Ansel Adams observed, "when preparation meets opportunity."

In a planned or subject-oriented painting, accidents are usually not desired because they must be incorporated into the subject matter to make them work. But in an experimental painting, it is difficult to discern what is an accident and what is not. I welcome most accidents, knowing that although they will make my job more difficult they will also give a special quality to each painting. The accidents are God's gifts. The challenge is to use them well.

The most common accident, which can usually be avoided by controlling the paper's wetness, is the crawl-edge caused by wet paint or water when it comes in contact with an area that is drier but not yet dry. Some of these are beautiful and look like leaf or cloud edges. Some are nasty and look like drips or splats. If this is the case, I hose the paint off, or if tampering with it wet may extend it to an even larger area, I dry it completely. Then I paint over it with a darker shape or wash out new shapes through it.

Once I admired the placement of a moon in the painting of one of my students. He had placed it far to the left of where one might expect to find a moon. "What made you think of such a novel placement?" I inquired. He answered, "I left my painting, and when I returned there was a drop of water attacking the pigment in that spot. So I blotted, lifted, and smoothed the offending spot and turned it into a moon." A less competent painter might have been too upset to find a solution.

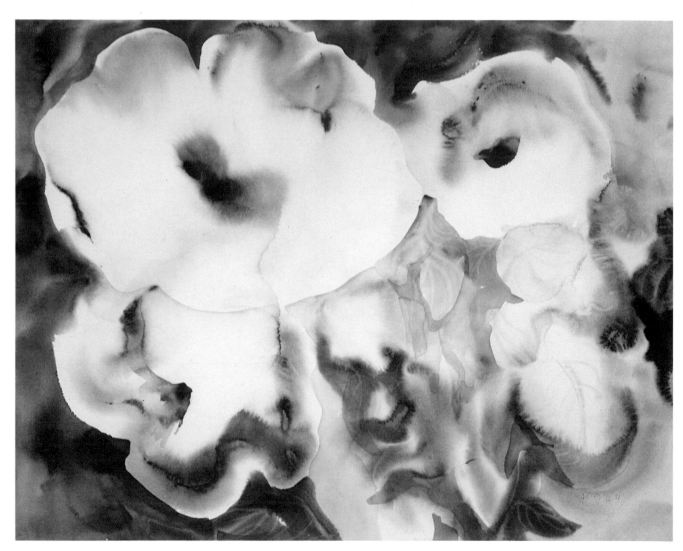

FLOWER POWER
22 x 30" (55.9 x 76.2 cm). Collection of the artist.

The white shape near the left edge, describing the turn of a petal, was the result of an uneven wetting of the paper. An unwetted spot remained white, so I made use of it.

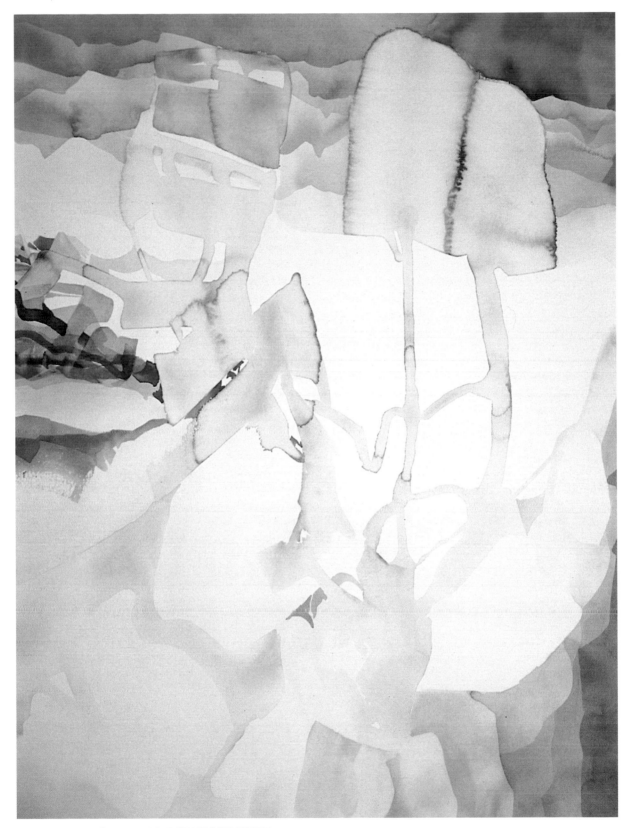

LOST IN THE BLUE MERINGUE
30 x 22" (76.2 x 55.9 cm). Courtesy of F. Dorian Gallery, San Francisco, California.

The two large white shapes with unusual edges (upper right) were formed by the evaporation
of pools of water and paint that I had left overnight. I had begun this painting as a horizontal;
I turned it vertically, and my abstract shapes became mountains.

Visualizing

Since I have never been good at memorizing, I invent images as I go along, relying on an imagination that has often been stronger for me than reality. I am probably incapable of visualizing an image before I start painting it. Even if I were to do so, I would begin to change it to something else by the second stroke. My journal-writing and photography help preserve memories of fleeting images.

If you can paint from an image in your mind, go to it, but I caution you: It is easier to use reference material to refresh the memory when needed, or to invent an image. This frees you to give constant attention to the paper, an essential for fine-tuning everything that happens to make your painting work. In my approach, each area is dependent upon its abutting area, and I make choices each time I add a new shape. I think harder when I don't have any preconceptions and am more inclined to make discoveries when I concentrate on the paper. I enjoy more spontaneity and seize opportunities to take creative detours while a painting is under way.

Using Photography

As the many photographs in this book show, I love to take pictures of natural objects and landscapes. Though I rarely, if ever, paint from photographs, they are useful for reference. Photographs provide me with a useful design tool. The process of making a photograph heightens my awareness of shape, and I call upon these shapes when I paint.

Photography helps me to see the familiar from a new viewpoint and to perceive nature more keenly. Sometimes a new twist on a familiar image seems so obvious that you wonder: "Why didn't I think of that? Am I an architect of vision—or of tract houses?"

When you turn a photo upside down, the water becomes a cloudy sky, the glacier's leading edge becomes a cliff. The pastel colors of an aging trash can resemble textured barn siding. Viewing a subject from a different point of view releases you from fixed notions of the object and allows you to see shapes clearly without the cloud of preconception. When we release ourselves from the knowledge of what something is, we can be more analytical. When you look at the photo of an object, you see the object; when you turn it upside down, you see a shape. The reality of the actual object will not interfere with your choice of how to use it.

Photographic images are invaluable when my recall fails and I need a detailed reference to finish a piece, especially if the subject is a natural scene thousands of miles away. The shapes of mountains and flowers, the values of shadows on streets and on snow, the curves of bridges and of grass blowing in the wind, all are recorded in my file of slide photographs.

The next time I paint a bird, my source will be volcanic ash resting on a glacier. The wind blew patterns on the soft gray ash, exposing white snow "feathers" below. A rusty tractor has the feel of a marsh at sunset. The greenery below the helicopter I'm in is like a leaf. A river tells me more about trees: A tree is a water system with moisture entering through the roots. The branches are tributaries.

I choose to look hard at both natural and man-made patterns. Similar patterns of dark and light often come from diverse sources. When I look at the curve of a flower I gather information about curves. I may impose the flower's curve onto the curve of a bridge. I may use the linear network of a bridge to depict veins in a leaf. Repetition of curves, angles, and rectangles in buildings, cities, and living things, even people, take new form in my paintings. This visual information, as I explain in a later section on photography, flows into my paintings more frequently when I have absorbed it though the taking of photographs.

When my photo of the leading edge of a glacier is seen upside down, the water looks like sky and the glacier like a cliff.

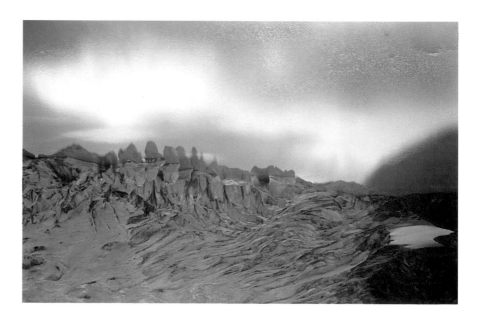

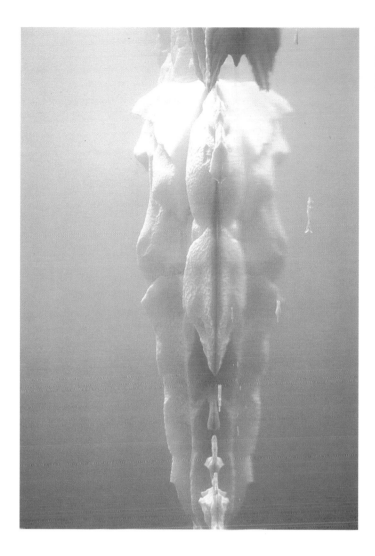

Try drawing the reflected iceberg with the photo turned on its side, as it is here. Now try to draw it with the photo turned to its proper direction. Which is easier?

Looking at this photo, taken while flying over Alaska, I was unsure what I had seen. I learned it was volcanic ash that had covered fresh snow. The wind had blown the patterns in the ash, exposing the snow under it.

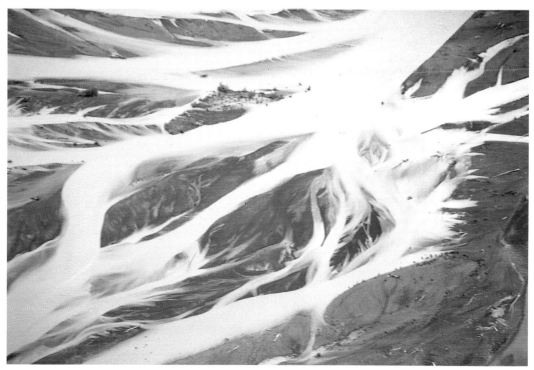

I photographed a rusting tractor near a quarry in Maine. It reminds me of a sunset over a marsh.

This trash can may be my reference should I want the side of an old building in a picture.

From a helicopter over Kauai, in the Hawaiian Islands, I saw a shape that resembled a giant leaf, veins and all. It may help me invent a leaf when I need one in a painting.

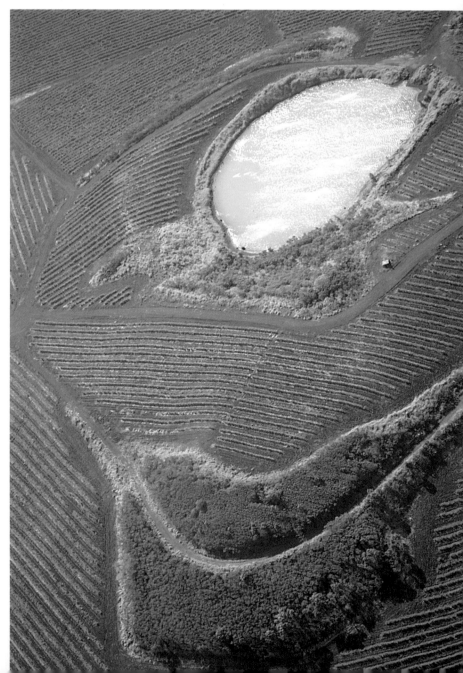

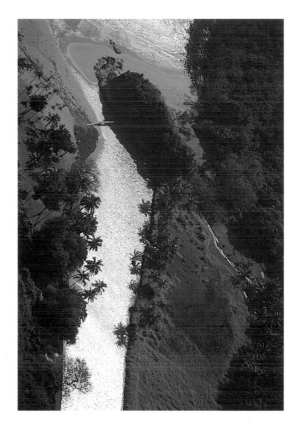

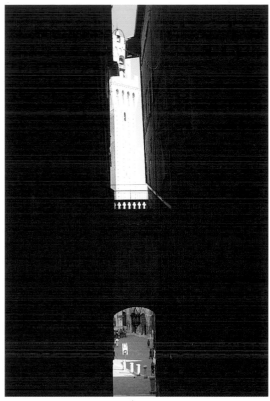

I photographed this silhouette (left) over Kauai. Notice the pattern of light.

A view through a passageway in Siena, Italy (right), has a similar pattern of light.

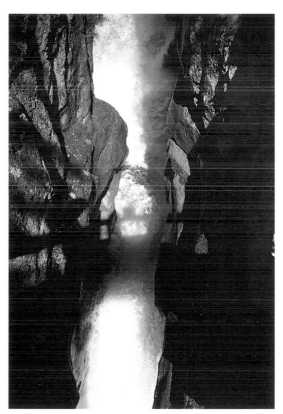

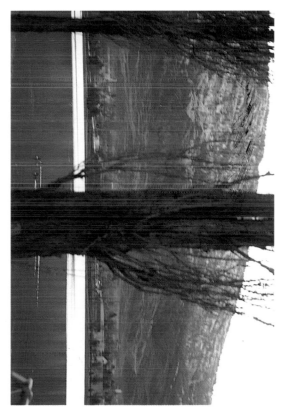

Another band of light was Maligne Gorge, in the Canadian Rockies (left).

If I turn Osoyoos Lake, British Columbia (right), on its side, it has the same pattern of light and dark as the previous slides. Perhaps a value pattern found so often in nature is a good one to borrow.

2 THE SELF-GUIDED ARTIST

In an essay about Thomas Hoving, former director of the Metropolitan Museum of Art, John McPhee tells of Hoving's student experience when his professor displayed an impressive piece of metalwork and asked the students for their reactions. "Latent vitality" and "mellifluous harmonies" were among the responses. Hoving felt misgivings and, despite self-doubt, he declared his genuine opinion that it was not a work of sculpture. "It's too mechanical and functional," he said. The professor answered that Hoving was right; the metalwork object was an obstetrical speculum.

Hoving later said: "I was never again afraid to say, 'I don't believe that.'. . . A work of art should be looked at as a humanistic experience, an object of its own."

If this is so, what am I to make of the information sent to me several years ago by an international art competition?

Entries shall be judged on the following criteria:

1. What is the overall spiritual and emotional impact of the work on a viewer?

2. How well has the entrant mastered medium and style in terms of: values, design/composition, color?

Number 1 above shall constitute 60 percent of the evaluation.

Number 2 above shall constitute 40 percent of the evaluation.

How do we apply these rules to the greatest works of this century? Can we judge a Kandinsky, a Picasso, or a Pollock painting in this way? Will the work have similar emotional impact on all viewers? Attempting to categorize the judges' responses like this treats a subjective process as if it were objective.

Even so, I am glad that competitions are available. They give us a way to stand up, be counted, and grow. The emphasis on competition, winning, rules, the ten best, first and second prize—this is what distresses. Many people place so much importance on being judged by others that they begin to lose perspective on what artistic activity is about.

I have been questioned about the risks one takes in painting solely for oneself. "But no one will buy what I really want to paint," is a common statement one hears. Yet I know of no artist whose work has lasting value who has worked in any other way. As soon as a child's painting is displayed on the refrigerator, the product is emphasized over the pleasure of the process. At the seashore, sand castles can be built without thought of critical appraisals.

If you can, watch a judge evaluate artwork. Does he or she balance intuition with thought and analysis and have enough knowledge and confidence to make selections without a checklist? If your own work is rejected in competition, you may feel better if you judge the judge.

Walking a Florida beach at dusk, I encountered a piece of art made purely for pleasure. It was gone the next morning.

How to Critique Your Own Work

It is essential to learn to critique your own work for the simple reason that, as you grow, scarcely anyone else will be able to tell you what you need. I remember when it became painfully evident to me that it was time to become my own teacher. Finishing a painting mechanically, according to my teacher's sensibilities instead of my own, I realized that I needed to find my own answers. Growth comes from the struggle to teach yourself what you need to know when you are ready to know it.

As one grows and changes, today's answers do not always fit tomorrow's paintings. One must continually accept and discard information and influences. I don't mean that suggestions can't be helpful. Yes, someone can tell you to move that tree to the left. Sometimes the insights of others are useful in pointing out choices of paths you can take, but for the most part, to quote the irrepressible Lily Tomlin, "We're all in this alone."

Some teachers are excellent at pinpointing specific problems in specific paintings. Some are helpful in pushing you along when you get stuck in the process. Some can tell you not only what is wrong but how to fix it. Some can only judge a finished painting.

Once, working on a painting that was my best to that date, I was stuck. Nothing needed fixing, I just didn't know how to proceed. A friend whose work I greatly respected looked at the painting and said to me, "Why don't you start over?" I was enraged. Eventually I guided myself to the completion of the painting. The next time my friend visited he said, "You should enter that in a competition."

I brought work to a master class. Some of it was unfinished, some had been exhibited. I was told, "You're doing fine." I was looking for answers, direction, a career boost, and I was disappointed. Later, I realized that what I did get, more than specific information, was time to be with and to listen to the philosophy of someone who had already learned much of what I was searching for.

I may not be giving the answers you want. I do not apologize, for there may be no answers. Knowing that this is so may be the most important growth step in the process of becoming an artist. When you begin to critique your own work, the answers are not always clear, but then on some days, in some paintings, the answers are clear. Each time a new plateau is reached, the answers may become elusive again. Self-scrutiny, honesty, and intuition are essential. Is every edge, line, and shape the best it can be to support what you have said? Does every part of the painting make sense to you? Have you edited what is extraneous to what you want to say?

Paintings may have beautiful childhoods and miserable adolescences, and then make wonderful adults. Many children, plants, and paintings go through awkward stages. Only a few get through unscathed and still beautiful without having been stunted.

> One ought never to forget that by actually perfecting one piece, one learns more than beginning or half finishing ten. Let it rest, let it rest and keep going back to it and working at it over and over again until there is not a note too much or too little, not a bar you could improve upon. Whether it is beautiful also is an entirely different matter, but perfect it must be.
>
> –JOHANNES BRAHMS

Finally, learn to give your work the ultimate critique. House cleaning is cathartic. I don't ever want to become so complacent as to believe that if I did it, it must be art.

Sometimes the technical competence that comes with experience can fool us and we fail to examine each piece for its own intrinsic value. Sometimes there is only a fine line between what I discard and what I save, and yet the two are light years apart. What causes the failures? Usually redundancy, either saying something I had said better before, or too much repetition within one piece. The lack of a spark of excitement, mood, or color in a painting is a signal to discard it.

It is particularly important for experimentalists to be ruthless in editing accumulations of work. I attended a retrospective of an artist whose work I had long admired. Though some of the paintings were quite wonderful, the exhibition was disappointingly uneven. I believe if he had been ruthless in editing his work when he was alive, he would have been viewed as a more important figure in retrospect.

There is a rare feeling I get when I complete a piece that seems special. Occasionally the feeling lasts. More often it fades when I reexamine the painting, find a flaw, fix it, am satisfied, put it away, find another flaw, repeat the process. These feelings contribute to my belief that the successes are gifts for our patience in putting up with the struggle.

> I have always tried to hide my own efforts and wish my work to have the lightness and joyousness of a springtime which never lets anyone suspect the labors it has cost.
>
> –HENRI MATISSE

I am encouraged to learn that it was difficult even for Matisse.

Avoiding Well-Trodden Paths

I am certain that there is a reason for every prescription I have heard. As your work changes and diverges from that of a mentor, it becomes clear that most rules and formulas apply to the needs of the one who prescribed them—but not necessarily to the needs of his or her followers.

Formulas can be healthy to own. If they are original, they become a personal language. But following them too closely can make both the work and the process a bore. (Sometimes, of course, formulas turn out to be habits that others have invented and we have copied.) When repeated according to formula, even important design elements can make work look stale or the design element itself too obvious. A formula painting is similar to a tract house. You already know where the parts will be. The elements of surprise and originality are lacking.

As a student, I followed certain design formulas. One was that of placing three shapes of unequal size in a composition. Luckily, at this time I joined a class with a teacher who stressed the importance of thinking about every choice made. When I showed him a painting with three well-placed unequal shapes, he chided me: "How cute: Mama, Papa, and Baby." I never again used these shapes thoughtlessly.

The lampposts are "Mama, Papa, and Baby" shapes—fortunately, they serve as a frame, rather than as the subject of my St. Croix River scene.

In this Napa Valley view taken from my bedroom window, I deliberately placed the light glow that is my center of interest close to the edge of the frame.

For a composition I call *Hypotenuse*, I used the formula of three different sizes, but not in a traditional placement. When I turned my camera at an angle, I glimpsed a different view.

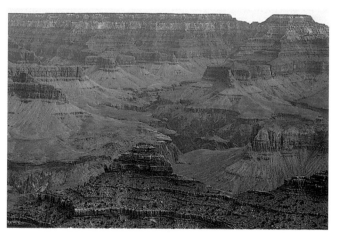

Had I not been using my lens as my eyes, I might have missed the subtle dip in the Grand Canyon's rim at the top right where sky and canyon meet. The space division depicts a classic high horizon, but to me the dip in the horizon, the most interesting part, is far from being a classically placed center of interest.

Another formula is useful but is sometimes better avoided: dividing space unequally. The formula assumes that unequal division is more interesting than equal division. In a landscape painting, for instance, choosing a high or low horizon can make a painting dramatic. However, a roomful of these will make a rather static exhibition. The closer one comes to equal divisions, the more difficult it is to make a painting dynamic, but to succeed will certainly set one's painting apart from the rest.

If your theme is an empty road, will a central focal point dramatize it better? Can an empty road be dynamic? Is asymmetry more dynamic? In a Japanese garden, the design is both asymmetrical and balanced. How about using imbalance, a wonderful way to capture interest?

When my family first took up sailing, in races we often trailed the fleet. I had many forward boats to observe as I learned to fly the spinnaker. One day when we rounded the mark, I put up the chute and looked forward to see what to do next. No one was in front so I looked back to copy the boat behind us. I was so unused to being ahead it did not occur to me that this time I was setting the course.

I was flying from Canada's Okanagan Valley to Vancouver in winter, trying hard to capture with my camera the magical, snowy patterns below. My seatmate said, "Why don't you ask to photograph from the cockpit? You will see better." That this might be possible had not occurred to me.

It takes thought and practice to become comfortable departing from the usual path. If one's path is defined by one's choices, then we certainly can choose to depart from the usual when it would inhibit or restrict an original approach that would make a picture better. This applies whether you are violating an old rule or simply departing from commonplace ways of seeing.

Michael Rossi
WINTER
Acrylic and collage on masonite, 22 x 30" (55.9 x 76.2 cm). Private collection.

In a common design pattern, midtones dominate, and smaller shapes of lights and darks are used for emphasis. Michael Rossi frequently used dark as the dominant value.

On a flight from Penticton to
Vancouver, I got this view by going
to the cockpit.

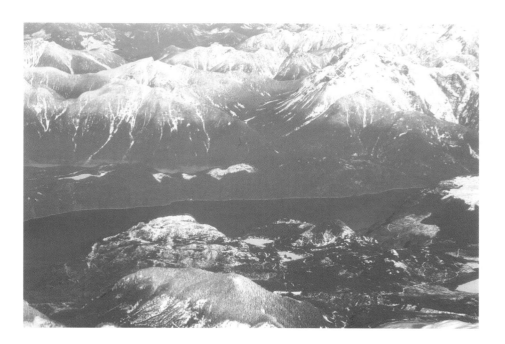

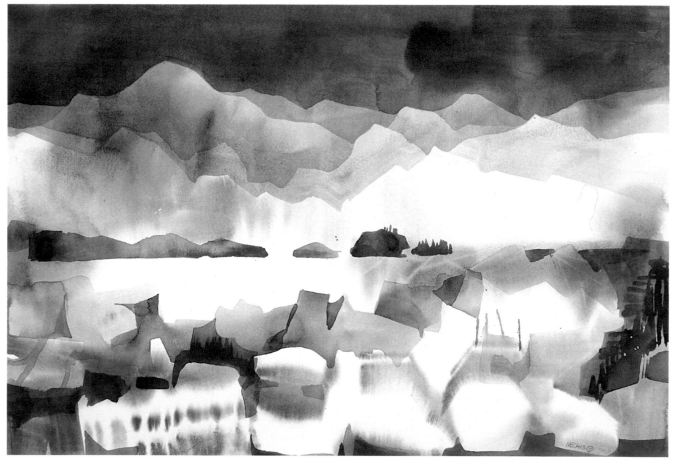

ALASKA MONTAGE
15 x 22" (38.1 x 55.9 cm). Collection of the artist.

This painting is symbolic of Alaska. I divided my paper in half because to me the mountains
and the sea are equally important. The mountain, Denali, is painted red because it is the most
dramatic symbol; the hot color better captures my excitement. The underwater icebergs
resemble pottery markings that represent the native culture.

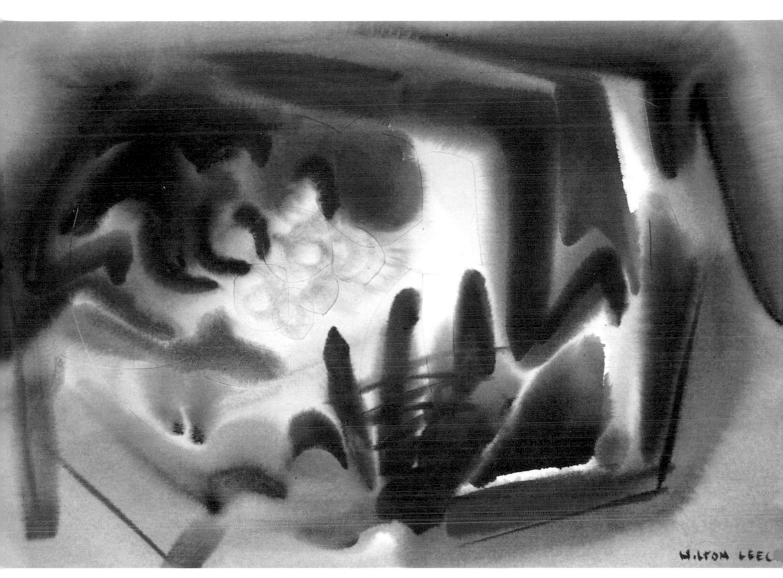

Hilton Leech
SCRUB ALONG BRUSH CREEK
22 x 30" (55.9 x 76.2 cm). Collection of Barbara Nechis and Andrew D'Anneo.

I have been taught that darks come forward and lights recede. I see the light in this painting
as the middle ground and the dark at the top as the background. My family has spent much
time discussing what the artist meant by his numerous ambiguous shapes.

ALL SKIES ARE BLUE
22 x 15" (55.9 x 38.1 cm). Collection of the artist.

When I think "sky," I rarely think "blue." I use colors I imagine, rather than colors that are typical.

ON THE HALF SHELL
22 x 30" (55.9 x 76.2 cm).
Collection of the artist.

Not your usual flower: I
emphasized the clamshell
shape of this flower when I
noticed it occurring and
made the center of it
resemble a crack in a shell.

GEORGIA ON MY MIND
22 x 30" (55.9 x 76.2 cm). Courtesy of The Artful Eye Gallery, Calistoga, California.

Another departure: I have avoided the cliché flower center—a dot with eyelashes.

Making Original Observations

Too often, students who have not developed independence in their visual perception fall back on cliché to describe objects: all mountains become symmetrical Mount Fujis, trees become the perfect Christmas spruce, and birds become flying W's; sky is blue, grass green, and tree trunks, unfortunately, brown. (Tree trunks are brown in stereotype but usually gray in nature.) Instruction sometimes provides less obvious commonplaces, but if we don't make original observations, we may never glimpse the truth about how the things we draw and paint are really made.

A cliché is a stereotypical or hackneyed form of expression. Clichés can be visual shorthand, to simplify expression. They are the boring fast food of painting. Since our visual environment is loaded with information, we must constantly sort what we see in order to understand even a tiny portion of our surroundings. The cliché can be a useful way to sort it out.

Surprisingly, I have found that few students have a visual understanding of their own environment. Those from New York, no less than those from Alaska, will paint a city as if it were only one street deep, with each skyscraper the width of the same-sized brush. Many plein-air painters do not pay enough attention to what is in front of them and will copy trees without ever really seeing them. One becomes more capable of seeing astutely not only by analyzing, but also by trying to paint occasionally without reference, then comparing the painting to its corresponding subject.

My first college art assignment was to draw a picture of my front door at home, which was 400 miles away. I had gone in and out of it daily for seventeen years, but I could not remember what it looked like. We can, however, visually reconstruct many things if we can put aside the fears that cause us to resort to clichés.

The human figure may not be easy to paint, but the fear that drives away common sense causes us to produce figures that don't remotely resemble what we unconsciously know about ourselves. I can't believe that there is anyone on earth who does not know that we all have necks. Yet ask a student who may have some experience in painting most other things to paint our species and often the result is an oversized head with no neck, legs that are too short, and every other part of the anatomy painted separately, rather than as flowing into a unit.

When we draw, we often isolate individual images, and so sometimes drawing causes misinterpretation. Again, analysis helps us know better what we see. For example, when I paint a distant village, students note my lack of attention to light and shade on my buildings. Why do I disregard the source of light, they ask, and scatter shadows wherever I choose? From observation I know that although there is a light and a shadow side to every building, from a distance what we see is a pattern of light; the sides of individual houses are not distinguishable. I place the lights to enhance my own pattern. Forgetting to analyze, a painter may break up the space like a checkerboard.

I painted these branches over a dried underpainting in which the edges are hard, achieving the illusion of depth. Note that each branch is connected.

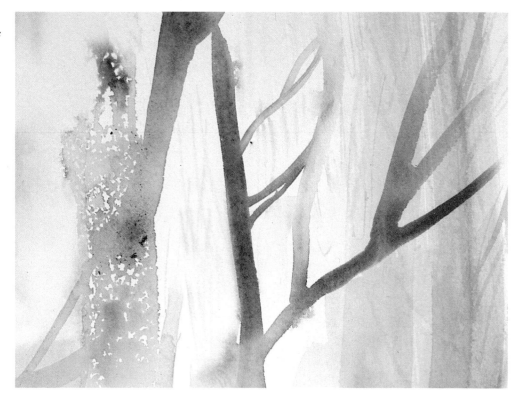

Observation is the key to avoiding such a stereotype. Trees should be the easiest of subjects to learn about, yet the clichés abound. In an attempt to show many branches, the unobservant painter dashes off unconnected lines. When we look at a tree, the branches we see are connected. Those too small to see appear as haze. Conscious observation enables us to draw it correctly.

Clichés in choice of subject matter can be equally objectionable. How did the first painting of a vase of flowers with a petal dropped before it ever get to be that way? Another cliché is crashing surf. Surely you know the painting I mean, with about a third of the paper devoted to sky at the top, then horizon with three unequal pieces of surf breaking the dark blue water. Each has its own matching-sized rock. Textured beach completes the foreground third.

Would it be better to avoid some subject matter? Can we use such a familiar subject well for a painting? Yes, by being aware of how it has been said before and finding our own way of saying it.

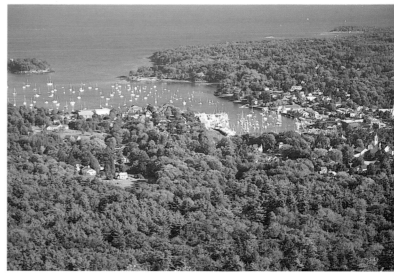

As I observe them, the houses in this view (from Mt. Battie) of Camden, Maine, show up not as blocks of light and shade, but as white sprinkles.

Nicholas E. Simmons
BEACH PATTERN #2: SEAWALL
Acrylic and collage on board, 24 × 48" (61 × 122 cm). Private collection.

This painting lets us experience seascape afresh. Breaking from the commonplace, the artist divides his composition with a strong vertical shape (right) that a painting of the sea rarely has.

Intuitive Color

I asked a student why she had placed a particular color in one area in her painting. She said that she had been taught to repeat each color in another part of the painting for balance. I asked Millard Sheets, who profoundly disliked the cliché of bouncing color, where he thought the practice came from. He said it may have come from erroneous conclusions based on the Impressionists' repetition of dabs of color all over the painting. The resulting work of the Impressionists, however, did not end up with thoughtless color repetitions. Still, the cliché persists. Millard's well-known maxim, "Never use a color the same way twice in a painting" is a useful reminder when habit rather than thought threatens to invade a picture.

In a painting I did long ago, the sky was blue and clear, and the rocks had mustard highlights. I deliberately drybrushed a stroke of ochre across the top of my beautiful sky wash. I was proud of my boldness in placing that stroke just so my color would be repeated. My teacher loved it. I was obeying the law. I still remember the stroke with regret.

A great deal has been written about the properties of color. I do not believe that those who remember scientific facts about color are necessarily greater or lesser artists. I experience twinges of insecurity when I hear an academician on the subject, yet I remain unmethodical in my approach.

I prefer to simplify the amount of information I need to remember and to rely on intuition. Since I know that all equal mixtures of warm and cool make neutral gray, I do not have to remember the individual colors that make gray. When a puddle of paint on my palette is cool, I pull warm colors into it for a neutral.

In Oriental brush painting, artists often dip one side of a round brush into one color, the other side into another, and the tip into a third. The resulting stroke will have a lovely color change. I usually dip my brush in several colors before making a stroke. If I use different combinations each time, my colors will not be structured, but neither will they be repetitious. The painter Jack Beal has said:

> I have purposely tried to keep myself relatively ignorant on the subject of color. . . . I have tried to keep my color on an intuitive level. . . . I have tried not to learn what warm and cool means or what the primary colors are. . . . I know some of these principles because you can't help but learn. But I try to let my color be as spontaneous as possible to the subject I'm painting.

How do you know what color to choose? The same way you choose what to wear. Your palette is your closet. When I am told certain colors go together, I think of fads and wonder if they are "in," and when they will be "out." Some of us may remember when red, pink, and orange or any combination of them didn't go together (and would never be worn together). Yet the Fauves, with Matisse a founding member, used such color combinations strikingly, to enhance mood and grab the viewer's attention. I choose my colors similarly, rather than to depict the subject. I rarely think "green" when I think "leaf," or apply blue when I paint sky. Instead, I think about shape and ask myself, "What color shall I make it?"

I once sat beside a woman wearing a white dress with red polka dots, red beads, red belt, red shoes, red bag, and red button earrings. Nothing was wrong with the

A tricolor brush stroke on unwetted paper. More often than not, I apply a multicolored brush to a wet surface, as in *Bermuda Sojourn*.

combination. But had she worn beige shoes and a navy scarf, or an orange one, I would not have suspected her choice to be the result of programming. Her once-fashionable matching of shoes to handbag has become a cliché. So have some color-mixing habits.

Color is a matter of personal taste. I tend to be particular about the greens I choose in rendering nature. Many students choose greens that are too cold to me. I have banished cold greens from my palette; I prefer sap green and olive. Sap green can be garish if used without neutralizing it a bit, but it has a nice way of separating into other colors at the edge when it bleeds. I employ this halo-like effect for leaf and flower shapes.

We choose color daily, and personal taste is within the core of each of us. We can and should paint what feels good. As we change, we feel differently about different colors. Guiding yourself along, pay close attention, and allow colors to happen.

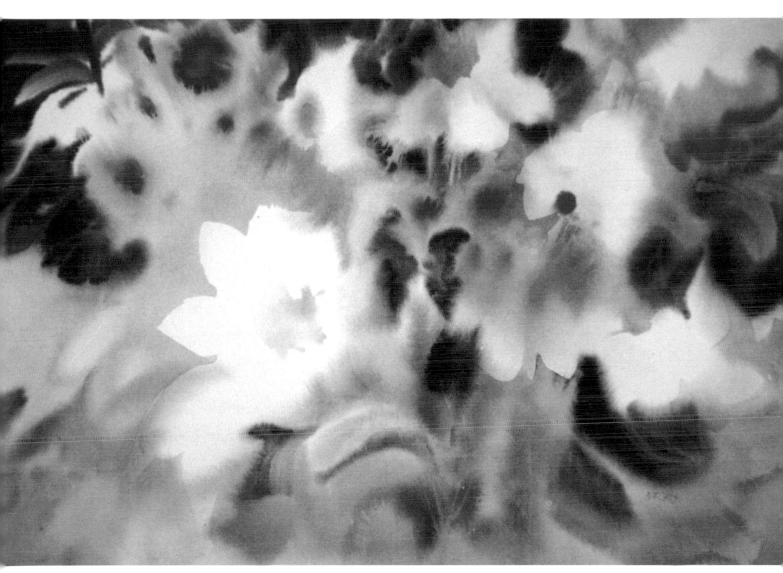

BERMUDA SOJOURN
15 x 22" (38.1 x 55.9 cm). Collection of the artist.

Notice how the reds change in color: I used different mixes of red each time I touched my brush to paper, and I also placed the red next to a variety of colors, emphasizing the impression of a changing of color. This was painted on location, where I was inspired by brightly colored flowers.

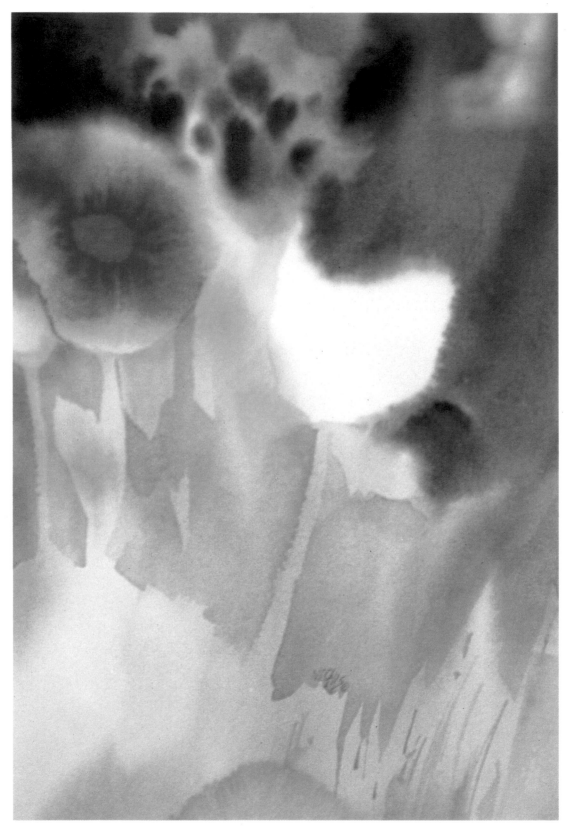

THE COLOR GREEN
12 x 8" (30.5 x 20.4 cm). Private collection.

I avoid middle-value greens, at which they are their most intense.
Darkened or lightened, greens are more neutral.

RED AND ROCKY
22 x 15" (55.9 x 38.1 cm). Collection of the artist.

I prefer to use neutrals rather than complements for color contrast. This avoids the harshness that hot against cold often causes. The grays make the reds "sing" rather than vibrate. By using imaginative color for a natural subject, I have distinguished this painting from most others of this subject.

Staying Flexible

Mohandas Gandhi said: "My commitment is to the truth as I see it each and every day, not to consistency." Most of the time we believe ourselves to fail when our product is not consistent with our expectations. Usually we keep on trying to make a painting work. When we get rid of the original expectation and try a new tack, sometimes success can occur. Maintaining inner vision is the key.

The first time I was responsible for hanging a solo show, I envisioned how I would place my pieces on the wall and give my *tour de force* a prominent position. Each time I inflexibly attempted to relate the rest of the work to that painting I was discouraged. Nothing seemed to work. Finally, I yielded: I removed my showpiece, hung it on a different wall, and the rest of the work easily fell into place.

When a painting fails, I no longer owe that piece of paper anything, nor does it owe me something. Then I am free to play and experiment. Instead of struggling to "fix" some offending area, I can ignore my original theme and begin again. The old painting may become a background for a new one. Sometimes I turn the paper upside down or turn a horizontal into a vertical.

If you are goal-oriented, limbo can be a fearful place to be. Leaving the cocoon of certainty can be painful for a time, but the rewards can also be great. One becomes a better painter by staying flexible, celebrating new experiences, seeing, thinking, and painting.

3 SEEDS OF CREATIVE GROWTH

Most visual artists are influenced by nature and by their environments. I have become aware of the importance of many other things that affect me and, accordingly, I have adjusted my working environment and life-style. The objects that surround me, the books I read, the friends and teachers I choose, and how and where I spend my time all influence my work. The works of other artists affect me also.

Allowing the "stuff" of a lifetime to accumulate without analyzing its visual worth can create a habit of not seeing, destructive to the creativity of a visual artist. Life deluges us with so much bad form that the only control visual people have is to deal with their immediate space. I am increasingly selective about structuring a visually appealing environment in which to live and work.

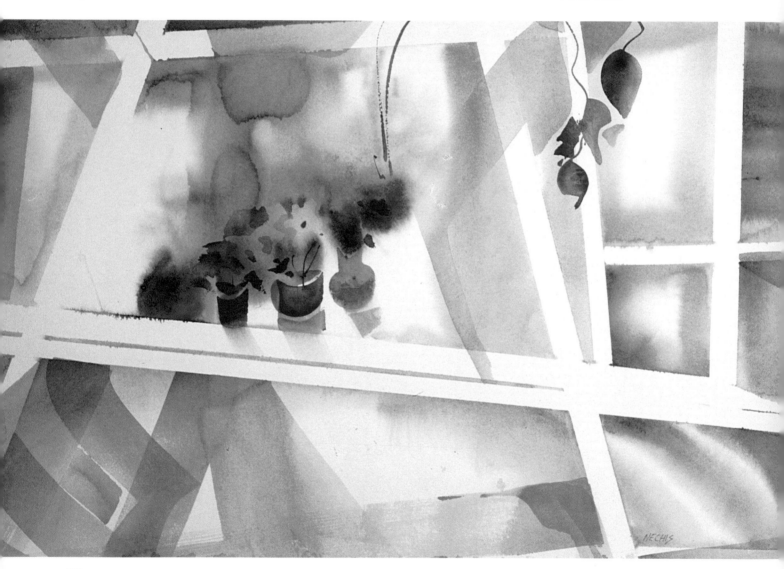

WINDOWS
15 x 22" (38.1 x 55.9 cm). Collection of the artist.

The content of this painting emerged as I painted. I concentrated only on shapes, space division, and color with no subject in mind. I added the flower pots last, still unaware of the source of my imagery.

Structuring an Environment

When I was about eight years old, I was promised a new rug, but then I learned its arrival would be delayed. I would wait no longer, and I removed the old one single-handedly. It had long violated my sense of color, and I preferred the bare floor. Even then I was rearranging my visual environment either physically or mentally. I would dream of combining the closets between my brother's room and my own so that I could create a studio.

A dozen years ago, I took a good look at my workspace. I lived in a pleasant house, but for years had spent my working hours in a windowless basement. I cut numerous mats a year with a $12 mat knife. I finally asked myself why I had tolerated such a handicapping environment for so long. I still wonder at how long it took for me to examine my life-style, given that I constantly search for ways to improve my work.

I began to look at other artists' spaces and found a relationship between commitment to work and the time and space related to it. Although the dissatisfactions that caused me to create a new studio environment were obvious, once I had taken care of them I began to see benefits that were beyond my expectations. My view of quality in all forms of art and my standards for my own work increased markedly after I found a talented architect to design a new studio for me. His dramatic design could not help but influence my work. A soaring ceiling and large windows altered my feeling of space, and I became comfortable working on larger and bolder paintings. Taking the studio as a standard, I began to look at the rest of my house with a critical eye and started discarding things that didn't measure up. As each unloved article departed, the remaining pieces became more important. Incompetent paintings by my own hand and by others came down from the walls, leaving space for new creations and acquisitions. The seed of collecting began to germinate in me.

At this time, I produced two new paintings which forcibly brought home to me the importance of my surroundings: *Windows* and *Still Life with Porcelain.* I had often used nature as a source of content and shapes in my work, and sometimes shapes I had seen in the past reappeared uninvited. Often they were not apparent to me until long after I had finished the painting. But the two new paintings were a result of my own editing of my environment.

Windows began as a demonstration for a class I was holding in my studio. My objective was to get my students to think about the importance of all the parts of the paper and how they related to the center of interest. Using masking tape to create angular shapes of unequal sizes, I created space divisions or frames for content, though a subject had not yet occurred to me. Only many months later did I recognize that a view of my studio from my daughter's room above had manifested itself from my unconscious to dominate the work. The marvel of the studio design had made its subliminal impression on me.

Still Life with Porcelain, also a demonstration, began with two colors I had not used before. I wanted to force myself to seek new solutions and expand my painting vocabulary—an excellent way to avoid repetition. I chose still life for my content and introduced fruit and floral shapes on wet paper. Immediately, I recognized the shape of the base of the large centered pot. It belonged to a porcelain piece I had bought because of a lovely combination of elements: the line of a graphic in its calligraphy, the flow of a watercolor in its glaze, and the sculptural quality in its form. The impressions I took in during the many moments I had spent admiring it now returned to the paper.

What interested me was that in both instances, shapes that were unique and created by someone else had found their way into my paintings. Did the borrowed shapes in my work appear because I had begun to sift the "wheat from the chaff" in my personal environment, making it easier to see and feel the quality in what remained? Would this mean that trite and badly designed elements around me would also find their way into my work, or would I naturally edit them out? The latter, let us hope, is the case for most of us.

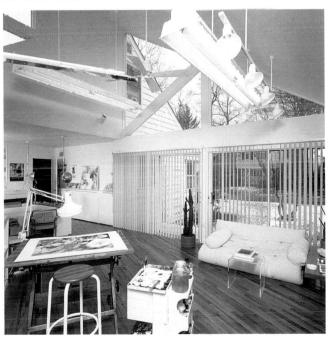

My East-coast studio, designed in 1979 by Richard Jansen, consulting architect to the Museum of Modern Art. Imagine the view from the upstairs window; I'm sure it inspired *Windows.* Photo by Jan Staller.

Collecting

I am a collector of many things. All the pieces that attract me have an intrinsic value, whether they are costly or free. I select out shells, rocks, driftwood, native crafts, and the work of all manner of artists and media—prints, sculpture, ceramics, furniture, rugs. I only buy souvenirs if their appeal goes beyond being a keepsake. Primitive and sophisticated objects live side by side in my house and studio. By rotating the work, I take care that it does not become so much a part of my environment that I cease to really see it.

Many people talk themselves out of acquiring objects without practical purpose. For many of us, thrift was positively reinforced in childhood training. Unfortunately, this may have also encouraged putting practical before spiritual or aesthetic considerations. Now I acquire things for the soul, and I applaud myself when these pieces become part of my visual landscape.

Years ago when I was refurbishing my bedroom, both to satisfy my eye and erase the previous owner's

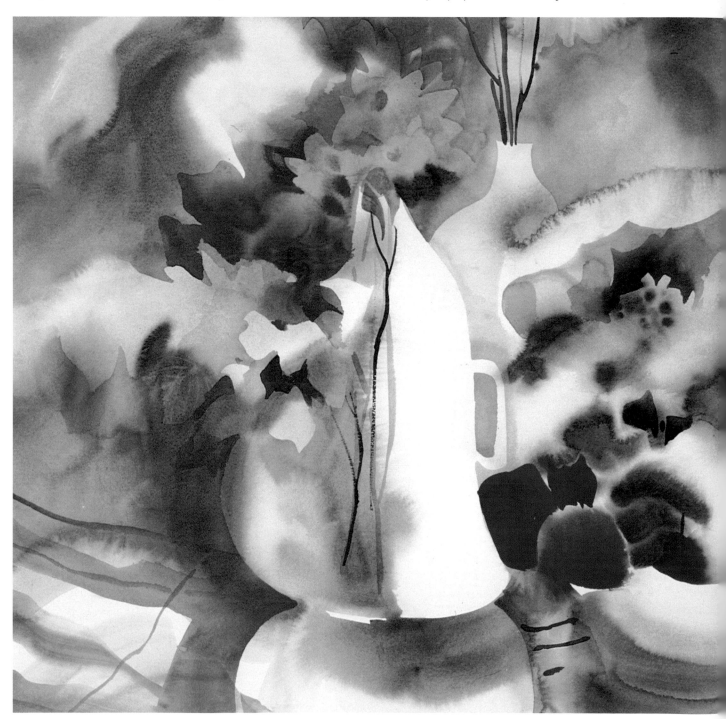

influence, I was surprised to find out how expensive quality carpet could be. When I mentioned this to a friend, she wisely said, "Think of the carpet as if you were buying a piece of sculpture." Most people are willing to spend more money on the carpeting, sofa, or picture frame than on artwork, which will certainly last longer in the pleasure it provides. If we as artists do not engage in collecting art, how can we expect those who are less visually oriented to do so?

STILL LIFE WITH PORCELAIN
22 x 30" (55.9 x 76.2 cm). Collection of Vie Dunn-Harr, San Antonio, Texas.

My first strokes were with cobalt turquoise and charcoal gray, two colors new to me. The former has become a favorite, and the latter I have not used again.

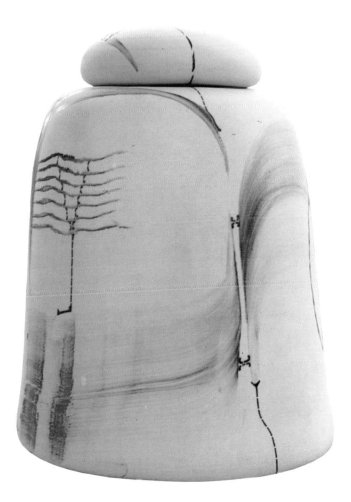

James Rothrock
PORCELAIN POT
14 x 10 x 10" (35.6 x 25.4 x 25.4 cm).
Collection of Barbara Nechis.

Other Media, Other Artists

Although I use watercolor as my medium of expression most of the time, I purposely diversify my idea sources to include other media.

When looking at a painting, my first reaction is really to content and form, not to the medium it is in. Moreover, I think of the artist's technique as I do of framing: if you notice it, it is probably wrong. Technique is extremely important for getting the message across, but it can be detrimental to growth to concentrate on technique, instead of content, as the most important part of painting. Unfortunately, many watercolorists fall into this trap. Although our motivation may be the passion most of us feel for this seductively elusive and beautiful medium, narrowness can result, limiting growth.

Milton Avery is one of my favorite artists. I saw his work in a retrospective exhibition in 1982 at the Whitney Museum of American Art, in New York City. Paintings like his *Seated Blonde* help me to think about simplifying shape. Although influenced by Matisse, Avery eliminated the decorative line common in Matisse's art, preferring to use spare, undetailed forms and flat color masses.

Museums and art books are an important resource, I find, for improving one's awareness of other artists' works, especially in other media. I now live in a very small town many miles from a museum, but I find opportunities to travel and explore some of the major exhibitions. My art books are a constant source of information that finds its way into my work. Many museums publish books about the major pieces in their permanent collections, as well as catalogues of special exhibitions. I like to leave books such as these open in my house and studio: one may be open to a picture whose unique color combination intrigued me, another to the work of an artist I need to know better, and so on.

Both *Poppies* and *Matisse with Soft Edges* undoubtedly have as their source my admiration and frequent exposure to the works of O'Keeffe and Matisse. Although red flowers are a recurring theme in my work, as they are in O'Keeffe's, it is the blackness of the center and the folded edge of my flower in *Poppies* that reminds me of some of her florals.

When I begin a painting, I am rarely aware of the influence upon me. Only after I become totally involved in the painting process, or after finishing the painting, do I realize the source of my idea. The influence responsible for *Matisse with Soft Edges* became apparent immediately: the exhibition "Matisse: the Early Years in Nice," at the National Gallery of Art, in Washington, D.C. A few days after seeing that show, the experience still fresh, I painted this still life.

By adding white gouache to my palette, I broadened my usual range of color. When I recognized Matisse's influence emerging in the simple shapes and unusual colors, I added decorative pattern and line—so evident in much of Matisse's

work—to further promote the resemblance. Milton Avery's influence is there as well in the flatter, undecorated areas.

Influences are healthy, necessary, and unavoidable. The architect Philip Johnson said:

> You always copy. Everybody copies, whether they admit it or not. There is no such thing as not copying. There are so few original ideas in the world that you don't have to worry about them. Creativity is selective copying.

Another exhibition, "'Primitivism' in 20th-Century Art," at the Museum of Modern Art, demonstrated to me an aspect of the nature of creativity. It juxtaposed the work of

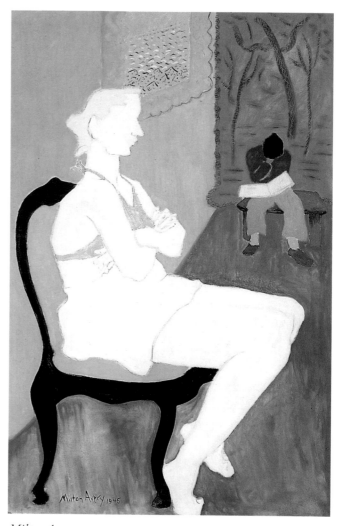

Milton Avery
SEATED BLONDE (1946)
Oil on canvas, 52 x 33¾" (132.1 x 86.2 cm). Collection Walker Art Center, Minneapolis, Minnesota; Gift of Mr. and Mrs. Roy R. Neuberger, New York City, 1952.

Avery's work has reinforced my understanding of the way Matisse avoided rote repetition of color by carefully choosing each color shape.

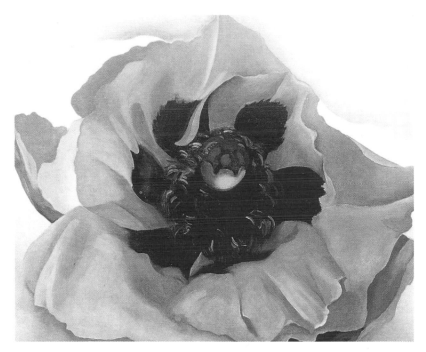

This wonderful artist's flowers are generally larger than life, as here.

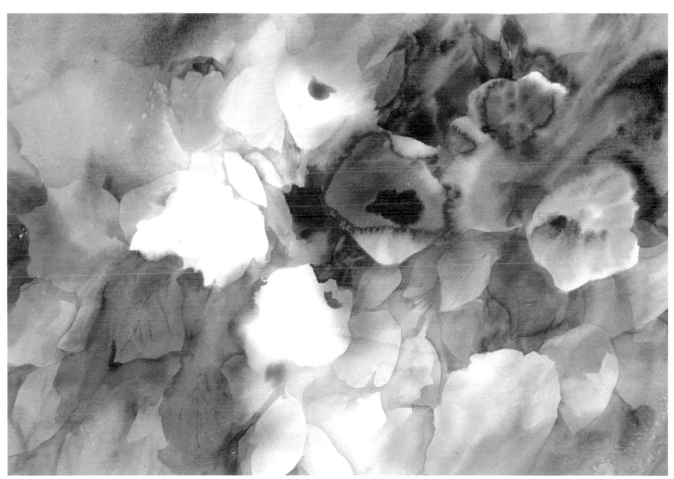

POPPIES
22 x 30" (55.9 x 76.2 cm). Collection of the artist.

While O'Keeffe's influence is evident in the poppy form, the rest of my painting departs from her florals, emphasizing numerous flowers and shapes.

contemporary artists with tribal art. Two things came out of it for me. First, although we may study color and design in depth, contemporary art is certainly no better either in design, craft, or form than that of the "primitives." Second, the universal art spirit pervades the creative mind, making it possible for artists who have never seen specific primitive pieces to produce distinctly similar work,

When I examine a painting I have finished, I try to discern its essence in order to give it a title to distinguish it forever from its siblings. Having painted hundreds of flower paintings, I do not always find this easy. Landscape is easier to title as it can always be named for a location. *Flow A* does not yet have the right title, but I recognized its roots almost immediately after painting it: Marcel Duchamp's *Nude Descending a Staircase, No. 2*, which reminds me of the shuffling of a deck of cards, and the fast-forward of a tape deck. My "flow paintings" evoke similar thoughts in me.

In *Flow B* the influence is similar, with a touch of Cézanne, who employed overlapping washes to suggest the uncertainty of the beginning and end of things. Here there is an "off-register" look to the flower edges; they don't line up, so it's unclear where each flower ends.

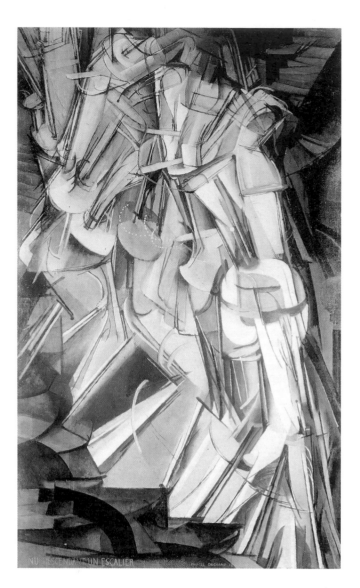

Marcel Duchamp
NUDE DESCENDING A STAIRCASE,
NO. 2 (1912)
Oil on canvas, 58 x 35" (147.3 x 88.9 cm).
Philadelphia Museum of Art: Louise and
Walter Arensberg Collection.

MATISSE WITH
SOFT EDGES
Watercolor with white and copper
gouache. 15 x 22" (38.1 x 55.9 cm).
Collection of the artist.

My objective was to create
simple shapes with unusual color
to indicate still life.

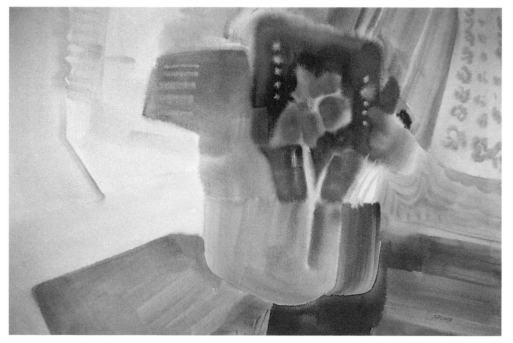

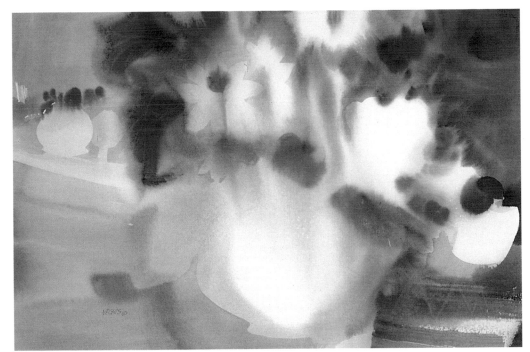

FLOW A
15 x 22" (38.1 x 55.9 cm).
Collection of the artist.

The effect of motion is
conveyed by the alternation
of soft and glazed edges.

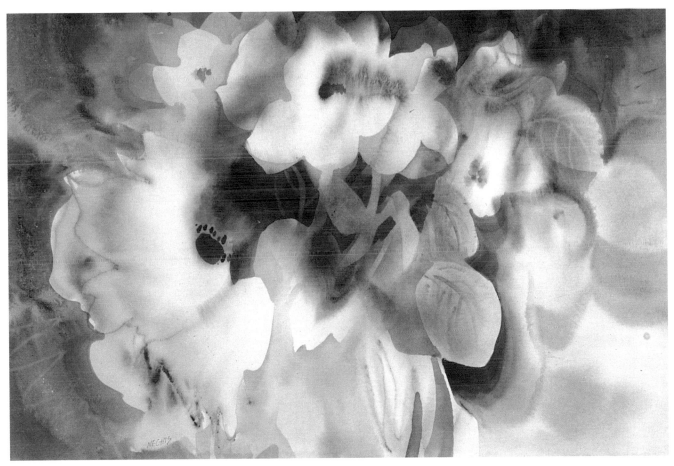

FLOW B
15 x 22" (38.1 x 55.9 cm). Collection of the artist.

Note the rhythms that animate this painting.

STILL LIFE
15 × 22" (38.1 x 55.9 cm).
Collection of the artist.

Milton Avery's influence is seen in these simplified, precise shapes. I eliminated all extraneous detail and painted the fruit to read not as isolated pieces but as a shape by allowing edges to merge. The unpainted whites are defined by hard edges, so they too appear as shapes.

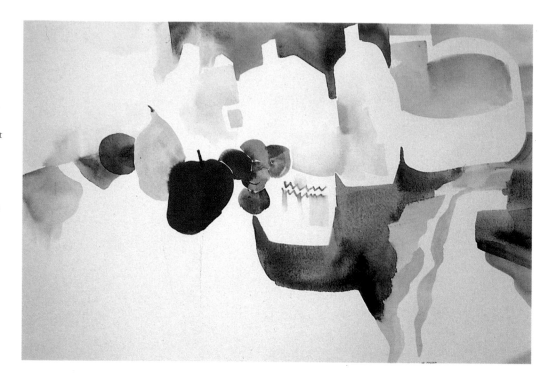

Teachers

Personal style comes with personal growth and evolves along the same lines, necessarily slowly, but with the joy of occasional breakthroughs. Many students are impatient with the process. They become so anxious to develop a recognizable style that they seize upon gimmicks or inappropriate forms. Some are so afraid of being labeled as imitative that they limit their education so as to limit being influenced. Some teachers are so fearful of being imitated that they fail to pass on much knowledge.

During the learning process, student work is often necessarily derivative. Experience brings with it the painter's own way of communicating.

There can be a fine line between imitative work and work that shows an influence. Imagining the work placed next to its source helps to separate work suitable for display from that which should be considered just a learning experience.

Source material needs to be assimilated. The final product will be wanting if it is an imitation of, rather than a response to, the source. This is true whether the source is nature, other artists' work, or your own previous work.

I have taken several photographic flight trips in both Alaska and Hawaii. One pilot in this case was the teacher, as he pointed out some of his favorite views so that the passengers could snap them. Some of the results were beautiful; still, I do not claim the vision as my own; it derived from his. However, one of my photographs, *Conception*, was my own discovery, over Kenai, Alaska.

When my pilot later saw my slide, he was amazed that I had found something he had not seen before

Author Umberto Eco, musing upon the meaning of penmanship, said:

> First you have the writing style your teachers drill into you. Then you try to imitate the prevailing style of the times. And finally, you settle into a style that is your own and no one else's.

I cannot think of a more apt description of the painting process.

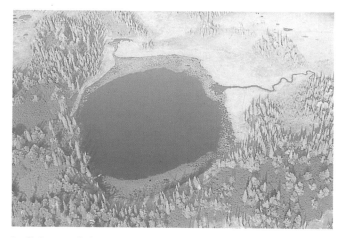

I call this aerial photograph *Conception*. I shot this lake somewhere over Alaska's Kenai Peninsula.

The Written Word

I am constantly amazed at the keen visual observations of good writers. Sometimes their written imagery remains with me longer than the pictures I have seen. Perhaps a picture is *not* "worth ten thousand words."

Literature is an excellent resource, both for the development of your thinking and for specific images. One story that has stimulated my imagination is the most visual piece of writing I have ever read: Franz Kafka's "Metamorphosis." My mind fills with images of Gregor Samsa turning into a giant insect. Kafka, like many other writers, worked with a great sense of isolation, which his story dramatizes. Painters often work in the studio away from the confusion of the world, with its multiple images. But then, as Kafka surely knew, separateness is an excellent "place" to polish one's craft and be in touch with yourself.

In the case of specific imagery, another Kafka short story, "Before the Law," was the source of Gary Freeburg's etching, *The Doorkeeper*. I acquired this piece because his unusual use of shape to tell a story fascinated me.

> Before the law stands a doorkeeper on guard. To this doorkeeper there comes a man from the country who begs for admittance to the law.

Freeburg created a positive-negative blocky shape of hand and underarm, unlike any other shape I have seen, instead of the open space that most of us would employ. This new shape instantly tells the story because the positive form blocks entry to the doorway beyond.

Journals

"My diary seems to be a journal of the wind, sunshine and sky," wrote the painter Charles Burchfield. Sometimes you can be influenced as much by the ideas of other artists as by their works. Journals can be a wonderful source of thought-provoking visual information. O'Keeffe's reactions to New Mexico and Van Gogh's to Provence, recorded in their letters, extend the impression for me of the work they did in those places.

The following entries in my own journal still evoke ideas for me, even though I may have forgotten the specific image that prompted them. They also give me ideas for choosing titles.

> Cherry lawn—the sky—red slivers of horizontal light threaded behind gray clouds, close in value to the sky

> Carolinas—greenbelt along a dried riverbed

> Red mud flats of the river

> River thick with spawning salmon, bright red, pungent from decay

> Southwest—ash gray. Are they trees dotted against the sandy mountains?

> The foothills look like green velvet today

> Sunrise lighting the west against gray

> Thin lines of rain rippled

Perhaps these jottings, along with other notes, quotes, and ideas will find their way into future paintings. Some have already appeared in my work.

My insistence on choosing quality in life has led me to build another studio in my new surroundings, designed by the same architect responsible for my New York studio. My collection of art works and books continues to grow, and I must continually make choices for good use of my time and space. These seeds ensure that when faced with a blank sheet of paper, there is always a stimulating bank of ideas from which to draw.

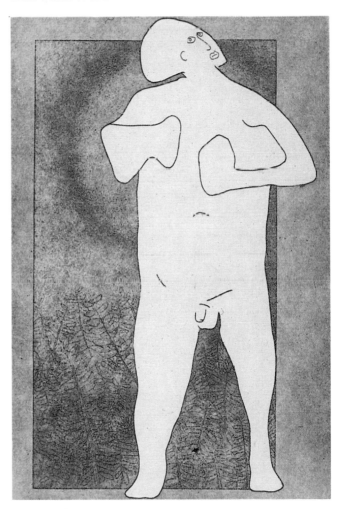

Gary Freeburg
THE DOORKEEPER
Etching with aquatint. 12 x 9" (30.5 x 22.9 cm).

TECHNIQUE AS A SOURCE OF IDEAS

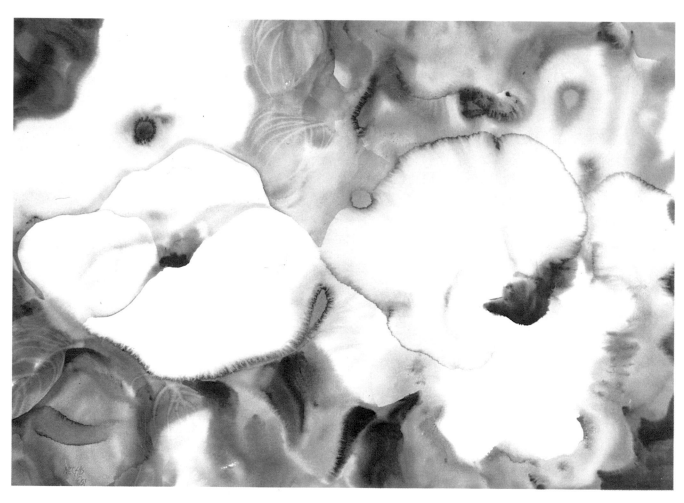

FLOWER FRIENDS
22 x 30" (55.9 x 76.2 cm). Collection of
Dr. D. and Mrs. J. Warren, Ontario, Canada.

THOSE OF US who are experimental painters inevitably discover new techniques and expand our painting vocabularies. Excitement about a potential discovery keeps many of us continually searching for new ways to change and grow as painters. ❧ Most of the techniques I currently use have roots in my earlier paintings and evolved, in many cases, from unconscious choices, accidents, observations, and needs. Although I rarely employ only one technique in making a painting, I describe each one separately here. One or more elements of one technique can be used with those of another, and techniques can be used in combination; this results in high adaptability to many painting styles. ❧ I have selected the following techniques because they run the gamut of watercolor painting —from hard to soft edge, wet to dry paper, and direct to overlaid painting. These can be a spring-

How can I tell what I think till I see what I say?

– *E. M. FORSTER*

board for your technique to evolve from your own needs. ❧ Unless I note otherwise, I have used watercolor to illustrate the techniques, because this is the medium in which I express myself. Many of these techniques can be adapted to acrylic. I show examples of my work which best illustrate the methods chosen and demonstrate the steps in the painting process. ❧ In most step-by-step paintings, the steps teach how to recreate a particular painting, and often I prefer an earlier step to the completed painting. When the painter stops the creative process to photograph each step in building the painting, attention to the process can be diverted, and the final product instead becomes the objective. ❧ Preconceived plans tend to reduce one's flexibility in adapting to the changes which watermedia abundantly produce. Paint and water behave unpredictably. They seem to have a life and interaction of their own. The challenge to me is in incorporating what they produce into a structure that completes my own imagery. In the course of the process I hope to paint something that I respect, but my goal is usually to see what will happen.

4 PAINTING WITH CLEAR WATER

My camera, which plays an important role in my visual life, led me to discover a new way of applying pigment. Some years ago, I photographed a group of trees at Pebble Beach, near the ocean. I do not remember what induced me to click the shutter, but afterwards I noticed the fluid movement of trees and branches in the projected slide. It occurred to me that by painting a similar shape with a brush loaded with clear water, touching the surface of the water with a brush loaded with paint, and carefully tipping the paper back and forth, I could produce a result that resembled my slide. The linkage of form and the spilling of movement from shape to shape, which this method encourages, continue to fascinate me. I begin many paintings this way, for all kinds of subject matter.

When you paint a shape with water, do not outline the shape. Instead, fill in the entire shape with water before applying pigment. Most people find it easier to work with positive shapes because "things" are made of matter. In painting an object, the natural impulse is to paint the object rather than to paint around the object. When drawn to a particular subject, whether it is a row of houses, boats, figures, or a vase of flowers, the typical painter is inclined to paint the subject immediately, without thought of background. Once the subject is painted on the white paper, the painter often leaves out the background because it is too difficult to fit in around the initial shape. If you think of the initial shape as only the beginning of a process, the building of the entire picture will follow naturally.

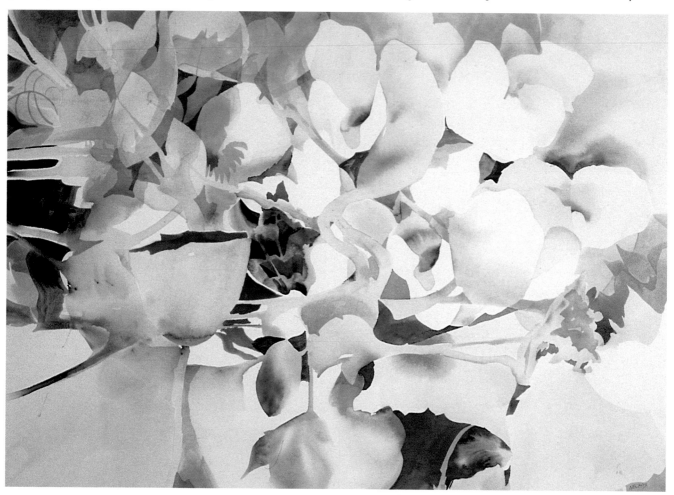

MY CUP RUNNETH OVER
22 x 30" (55.9 x 76.2 cm). Collection of the artist.

The cup at the left and the opening bud at the far right were drawn in a single shape of water in the first layer. The jack-in-the-pulpit-shaped flower in the top middle was my solution to the beginning of an accidental drip. I liked it so much that I repeated it lower down and to the right.

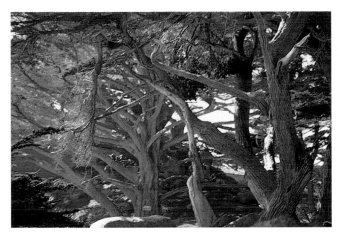

In this scene, photographed along 17-Mile Drive on the Pacific coast at Pebble Beach, California, notice the seemingly fluid rhythm of the branches.

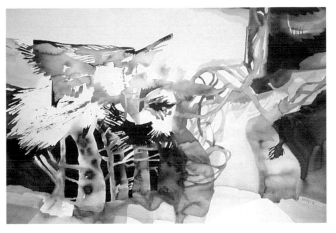

PACIFIC TOTEMS
22 x 30" (55.9 x 76.2 cm). Private collection, England.

This is one of my earliest paintings using the method of painting shapes with clear water first.

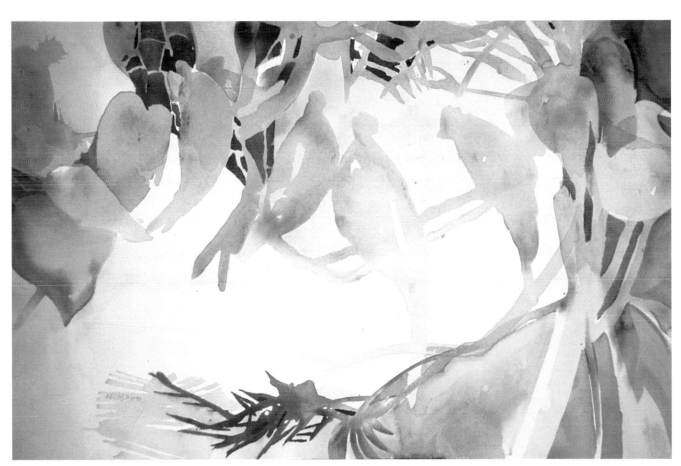

A NIGHT IN ACAPULCO
15 x 22" (38.1 x 55.9 cm). Collection of Ruth and George Sawatzky, Canada.

Painting on a veranda, seeing and hearing the tropical birds, I linked my forms and repeated the rhythms in both the branches and the bird legs at the far right. Although the flow of paint in the initial layer appears to be loose, I maintained control at its contours.

Controlling Rivers of Paint

When I need more control to ensure that the paint does not spill from its water trough, I extend the edge of paint slightly beyond the water edge to grab the dry paper and hold the shape in place. Sometimes a careless spill forces me to invent new subject matter. Drips under a row of houses, for example, have turned into crevices in a rocky cliff, which then supported my "cliff dwellings."

When satisfied with the shape of my initial layer, I pour off the excess water. Obviously, for this to work, the shape must extend to at least one edge of the paper. Extending shapes to the edge is a good practice; well-designed paintings usually fill the page. You will find it easier to control the flow of the paint and water if the paper is not attached to a board. That way, a corner or portion of the paper can be lifted to allow pigment from that area to flow. Areas that please you do not need to be tipped to accommodate the needs of other areas. Controlling rivers of paint would have been difficult had I continued to stretch paper, as some of my former teachers insisted.

Some of the advantages of painting with water are obvious. If the original shape of the clear water drawing is not what you want, the paper need only be dried and reused.

To begin, draw the shape of the first layer with water.

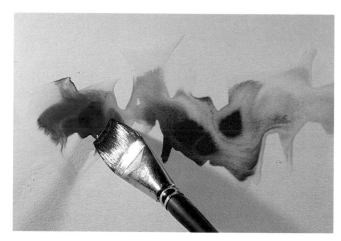

Put paint into the watery layer.

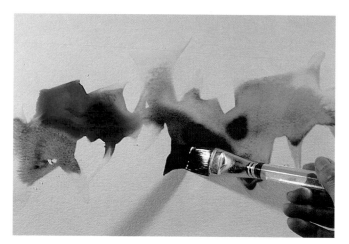

Extend paint into the dry area and you will secure the edge.

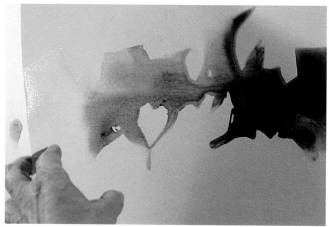

Tilt the paper to mix the colors.

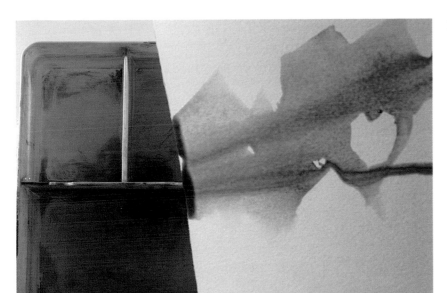

Pour off the excess water and paint.

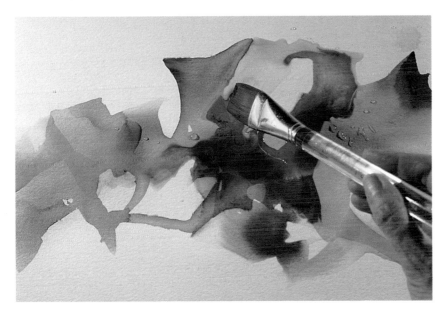

Experiment with a second layer of clear water and pigment.

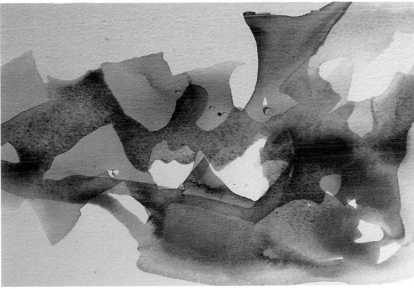

You can continue developing a picture in this way or turn to other techniques.

Color Mixing

Placing colors directly where I have applied water to the paper's surface, I allow them to blend in the tipping of the paper. Because my brush touches only the water, rather than the paper's surface, I do not get muddy or overworked areas. If the brush mistakenly hits the paper surface below the pool of water and a dot of paint remains, one must agitate the dot with a brush to eliminate it before the excess water is poured off. Opaque colors such as cerulean blue are notorious dot makers, so I tend to avoid opaques and use more transparent colors when I paint in this manner.

I use these methods to quickly block in the shapes I am attracted to when painting on location. Capturing the rooftops of Siena or figures in a Mexican market in this way seems to deliver their essence.

When the initial layer has thoroughly dried, I repeat the process with subsequent layers of water and paint, as needed, adding complexity to the design. The painting is usually completed by direct painting of finishing details.

Drawing with water to begin paintings is immensely useful because it can inspire new directions, while the method goes undetected in the final painting. Unlike many methods which practically shout their source, this one quietly takes on the personality of its user.

This shape was drawn with water, then yellow, red, and blue were applied full-strength as I randomly touched the brush to about half the wet surface. By tipping the paper back and forth, I blended the colors.

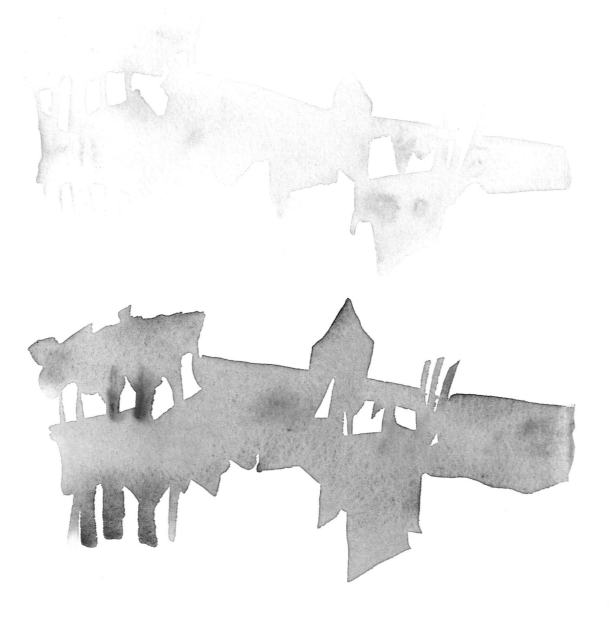

This shows the same process and colors, except that I touched more of the wet surface with pigment, so that the value is darker.

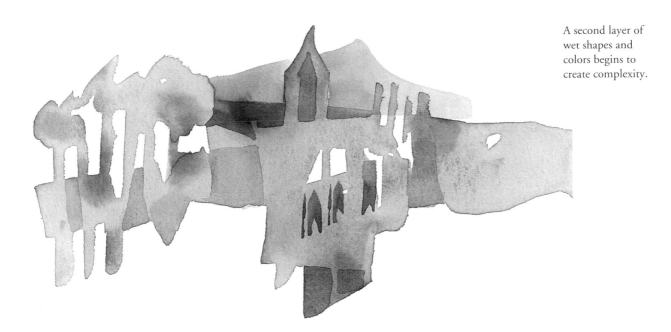

A second layer of wet shapes and colors begins to create complexity.

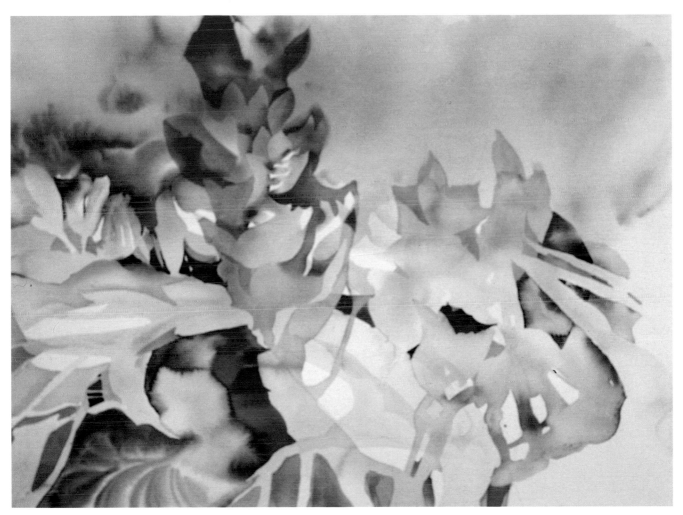

GINGER
22 x 30" (55.9 x 76.2 cm). Collection of Margaretha Stramecki, Phoenix, Arizona.

Unlike many of my water-drawn pictures, this one features stronger colors, mostly warms, so that the tipping process would not neutralize the color.

I have begun the painting (right) with water-drawn shapes. I will vary my technique to develop it further.

Glazes, even line, are then added (below). I like some of the blank spots, leave them unpainted, and discover that the painting is complete.

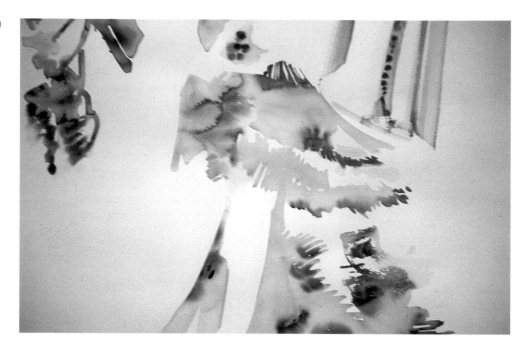

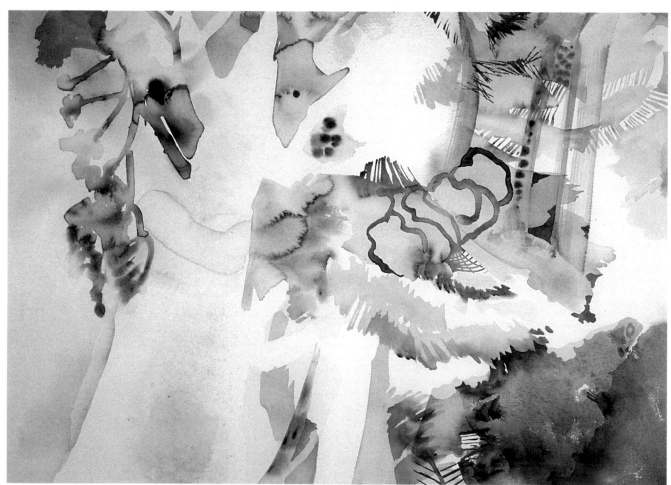

TREE SPIRITS
22 x 30" (55.9 x 76.2 cm). Collection of the artist.

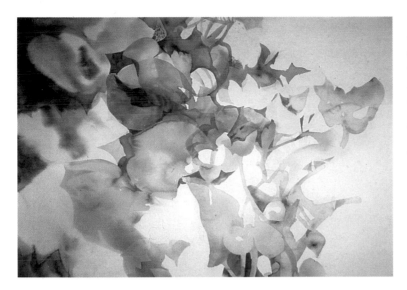

I started this painting with clear water shapes, thinking of circular and flower forms. I could have developed shells or pebbles (and perhaps I will in another painting). I ended up creating more shapes (below) by applying dark glazes; my favorite shape is the light leaf at the bottom, which was a positive that I turned into a negative.

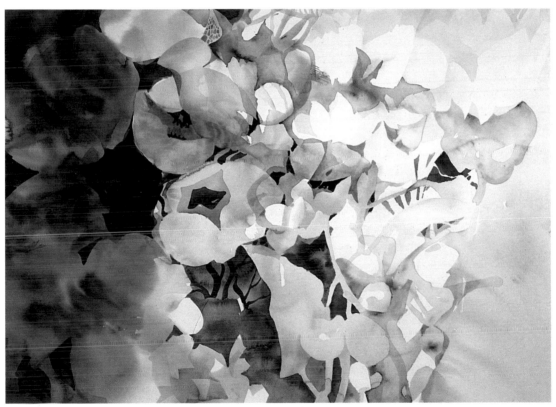

GENESIS BLUE.
22 x 30" (55.9 x 76.2 cm).
Collection of Carol Hamilton and Peter Johnson, Massachusetts.

After I completed the painting, I remembered having taken this photograph. Perhaps the circular forms were the "genesis."

Layering Shapes

I am challenged by developing my initial positive shape into a negative light shape, so that the painting is visually interwoven with the paper rather than sitting on the paper. This lends complexity and even an element of mystery to a painting.

I think of the shape created by the first layer of pigment as similar to a vignette, which consists of a simple positive shape on, rather than of, the paper. Vignettes can be cut out of the paper, unlike more complex paintings which involve the entire paper and cannot be separated from it. Like hors d'oeuvres, they only occasionally satisfy.

Subsequent layers of pigment can surround and overlap the initial shape and convert it from a positive to a negative. It becomes defined by the darker values around it. No matter how light the initial positive shape is, it will not appear light if it is surrounded by white paper. However, as paint is added to the adjacent paper, the initial shape acquires the illusion of being light. A range of midtones and lights within it will give further interest and movement. Mid-tones and darks adjoining the initial shape further assist in establishing the light.

The negative, light shapes you create may thread their way through a painting and provide the points to which the eye is drawn. When we exclaim: "Look at the moon!" or admire snow-capped mountains or a Greek village on a sunny coastline, we are enjoying negative forms. *Tao Te Ching,* a classic of Chinese philosophy more than 2,000 years old, describes the essence of negative space:

> Thirty spokes converge upon a single hub;
> It is on the hole in the center that the use of
> the cart hinges.
> We make a vessel from a lump of clay;
> It is the empty space within the vessel that
> makes it useful.
> We make doors and windows for a room;
> But it is these empty spaces that make the
> room livable.
> Thus, while the tangible has advantages,
> It is the intangible that makes it useful.
>
> –LAO-TZU

Not all your paintings will begin with a water-drawn shape. Underpainting presents you with a different range of creative choices, as shown on the following pages.

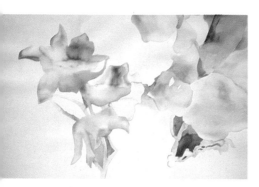

The initial water-drawn shapes (above) include the yellow flower, which becomes integrated as a light shape into the finished painting (right). I developed all leftover white space into subject matter (in this case, white floral forms) rather than leave holes in the composition.

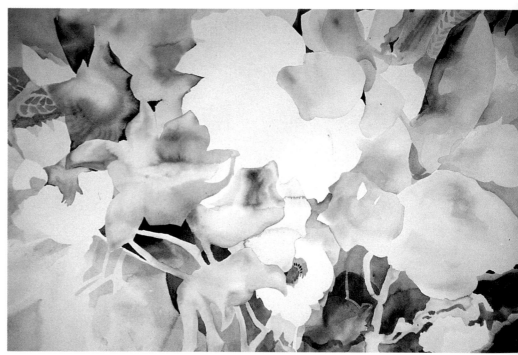

ALABASTER'S GARDEN
22 x 30" (55.9 x 76.2 cm). Collection of the artist.

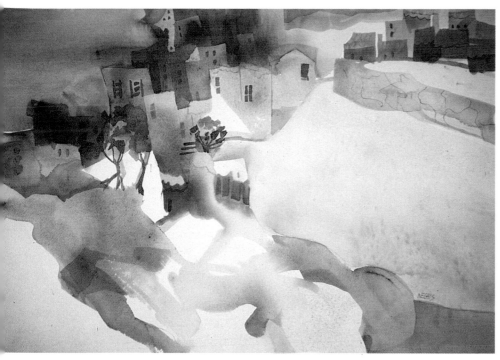

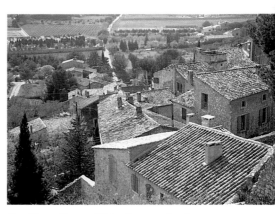

Eygalières, France. This photograph of a similar place shows how the same method of layering shapes would be suitable for rendering the rooftop view of the village.

A DAY IN PROVENCE
15 x 22." (38.1 x 55.9 cm). Collection of the artist.

I painted this on location in Gordes, a village in the south of France. Starting with the shapes of the buildings, I drew one large shape with water and later broke it up for complexity.

The transparency of glaze layers contributes mystery to a painting. The largest shape, painted last, lets other shapes and underpainted color show through, lending it variety of color and value.

5 GLAZING TECHNIQUES

Glazing, or the layering of thin transparent washes, has long been a favorite method among English watercolorists for building subtle layers of transparent color. Unlike direct painting, in which the values, shapes, and colors are placed on the paper as they will appear in the final painting, glazing is a bit like a chess game: each event revises the entire picture until the final outcome. Thus, a red shape may become purple if blue is glazed over it, or gray if a green is overlaid. In direct painting the purple or gray would be mixed on the palette and applied, or the colors to make the purple or gray would be placed on wet paper so that the flow of water would allow them to merge.

The layering already described is an example of glazing, though I use the term "glaze" to describe using a pool of pigment to paint the shape, instead of establishing the image with clear water and introducing pigment into it.

Glazing is most useful for correcting color, simplifying value shapes, defining close-valued shapes, and creating illusions of light. Many of my paintings make use of this technique, either as the dominant way of working or for detail.

Underpainting

When I use glazing as the primary method in developing a painting, I usually begin with the wet method to establish a base of color or texture and gradually add glazes to develop the subject and design. This first layer becomes the background for layered shapes. When I use the process of negative glazing, which is described later, the lights are formed from the underpainting.

Preparation

To wet the paper surface, avoid sponging, which tends to remove the sizing. Instead, use a large brush and clear water and wet it evenly, then tip the paper to pour off any excess water. The retained sizing creates a momentary barrier so that staining colors will not be absorbed by the paper; they can be washed away if the initial color choices do not please you. Moreover, if the sizing is not removed, the glazed edges will remain crisp.

I don't limit my choice of pigment in any way. Although many painters believe that staining and transparent colors should be in the first layer only, followed by opaques in succeeding layers, most colors can be thinned enough with water to appear transparent.

You should not have any difficulty with the disturbing of the underpainted layer when you add subsequent layers if you allow the initial layer to dry completely and if you carefully apply the covering washes. The larger the brush, the fewer the strokes, and the less the chance of disturbing the base. If acrylic is used for the underpainting, less care is needed in subsequent watercolor layers, because dry acrylic cannot be disturbed or muddied.

Unstructured Underpainting

Since no subject is hinted at in an unstructured underpainting, it can be used as support for any content. I paint randomly on the wet surface with colors that please me, varying their intensity and value. If I accidentally make an unwanted stroke that sets, I spray extra water on it and tip my board, holding it in one direction until the offending stroke blends with the rest. In this layer I avoid hard edges and shapes that may indicate subject matter. Hard edges are easy to make, but difficult to remove. Then I allow the paper to dry thoroughly.

If you think the underpainting is too bland when it dries, just repeat this step. If it appears too strong, or if you are unhappy with your color choices, you can hose it off before it dries and start over.

Subject-Oriented Underpainting

Sometimes the soft colors will indicate or hint at a subject that you may or may not wish to develop. Sometimes you may deliberately create soft-edged shapes to suggest trees, rocks, or other objects. In subject-oriented underpainting, you can introduce value contrasts to indicate soft shapes, whereas in random underpaintings, subtle gradation predominates.

The abstract underpainting becomes a blueprint for development with both positive and negative glazes. Many realistic painters begin with an abstract underlayer which is not apparent in the finished painting.

Random, changing color was my only consideration in this unstructured underpainting. I placed the yellow-orange in only one area to avoid monotony. Shape will be developed in subsequent layers.

In this underpainting, I suggested natural forms —perhaps rocks, and some tufts of grass. Unlike the unstructured underpainting, this shows some soft-edged value shapes. Since I do suggest subject matter here, I will need less development in the glaze layers to complete the picture.

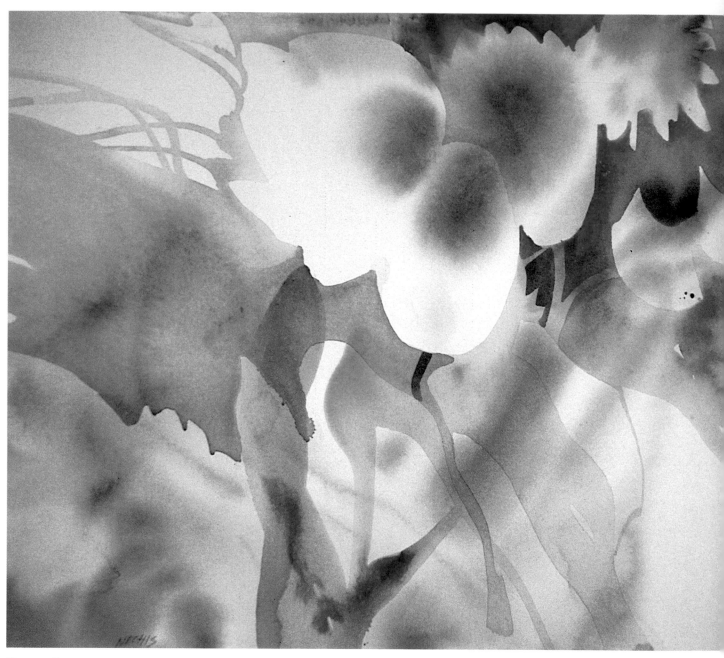

FLYING BOUQUET
15 x 22" (38.1 x 55.9 cm). Collection of the artist.

Perhaps these are flowers. The wet underpainting suggested the idea. The second layer of abstract, water-drawn shapes form the edge that creates the illusion of flower forms. Note that actually there are only ribbon shapes which suggest flowers, the definition of the outside edge of flowers, and the wet underpainted shape.

SEASON'S CHANGE
15 x 22" (38.1 x 55.9 cm). Collection of the artist.

All the color is in the underpainting, where I suggested the rocks and trees. Notice how I placed the glaze around the orange and gray area to tie them together with a tree shape.

Making Adjustments

Although I prefer to get the colors I want by direct application of color, sometimes my original color choices in the first layer are no longer what I want as I further develop the painting. I will glaze over an area either to intensify it, by adding more color, or to neutralize it, by adding a complement. If a color is isolated, I will combine it with an adjacent area by glazing the isolated color over some of its neighboring color or vice versa.

Glazing is invaluable for unifying and simplifying areas that are fragmented by too much detail. I love detail and small shapes. In the past I tried to simplify my shapes at the start of each painting. When I finally realized I was entranced by small shapes, I figured out how to use them. By making shapes to my heart's content, then unifying them with larger glaze shapes, I satisfy both the need for pattern and the need for simplicity without sacrificing the design.

In *Canyon Chasm,* I indulged myself by starting with the smallest of shapes on a large piece of paper. I had recently visited the Grand Canyon and came away aware of the futility of trying to capture on paper its awesome size and its impact on the emotions. I was sure that simplifying its grandeur would result in failure. So I approached it from the idea of building up small shapes to form larger pieces the way all matter is composed of particles. I glazed broad washes over smaller shapes to bring them together, and the resulting painting, containing only nonobjective shapes without a single rock or crevice, captures the spirit of the canyon.

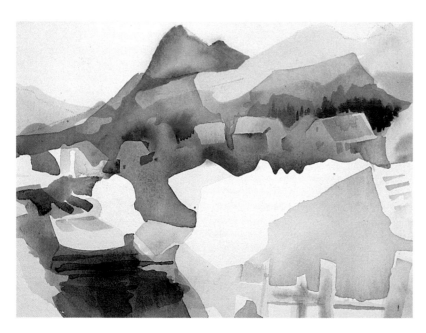

A warm glaze over a cool area brightens it up and ties a group of small building shapes into a single larger shape.

The warm glaze finally seemed too warm for the painting, so I added a cool layer to neutralize it.

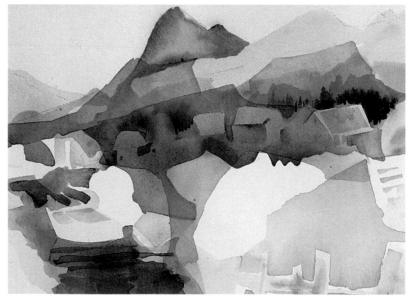

CANYON CHASM
31 x 45" (78.7 x 114.3 cm). Collection of the artist.

In painting the Grand Canyon, I linked many small abstract shapes
by superimposing a glaze of larger shapes.

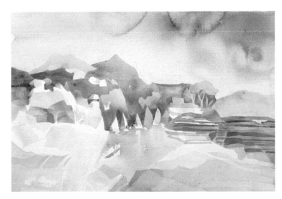

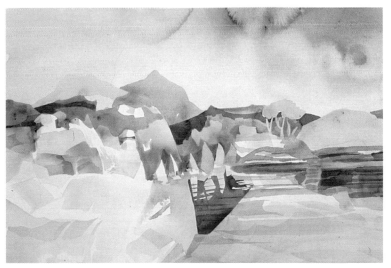

Boats, trees, buildings, mountains, water, and reflections
make for a too-diversified picture (above). A final glaze
links the diverse subject matter (right). The painting
now reads more satisfyingly as groups of shapes.

FISHING VILLAGE
15 x 22" (38.1 x 55.9 cm). Collection of the artist.

Negative Glazing

Negative glazing is a process of making light shapes on the paper by glazing around the shape to be formed. There are no outlines in nature, so in painting it is important to use value rather than line to differentiate shapes. Line is better used for its own characteristics than as an aid to solving value problems.

Many artists form negative shapes by placing positive shapes adjacent to an unpainted area, creating the illusion that the unpainted area has form. This requires planning two shapes at one time. Because I find it easier to deal with one shape at a time, I prefer to form my negative shapes independently of the positives.

I build each shape by placing a broad stroke of pigment of similar color and value to the underpainting around the shape I wish to make and quickly grade away the liquid bead at the outside edge of this stroke. (I have found that the surface of Arches 140-lb. cold-pressed paper promotes a better gradation of pigment than most other papers.)

It takes some practice to calculate the right combination of pigment and water. If the glaze is too dark or if it is composed only of staining pigments, it will be difficult to grade away the ring of pigment. Since I combine several colors in my pool of glaze, the odds are great that both staining and nonstaining colors will be included; any negative results of using only one type of pigment will be counteracted by the combination. If the glaze is too pale, it will not contrast enough with the negative shape it was intended to play up.

You can draw each shape with a pencil before you glaze, but if you draw more than one, you may tempt yourself to silhouette all the shapes as a group, rather than to glaze around each item. Then you will tend to want to use line to indicate the edge of each shape, where tone would be more appropriate.

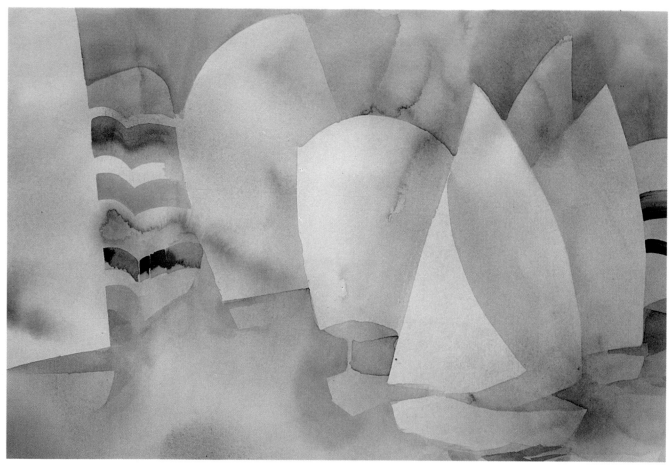

SAIL SHAPES
15 x 22" (38.1 x 55.9 cm). Collection of the artist.

This painting was developed as shown in the following step-by-step re-creation.

Pools of glaze: I use a different brush for each color so that I can quickly move to the color I need.

I place my first stroke of diluted pigment on an underpainting similar to the one in *Sail Shapes*. Using a color and value similar to that of the underpainting in this area, I "carve out" the shape of a sail.

I grade away the outside edge of the stroke with a clean brush and clean water. The farther I wash away the edge, the less obvious the stroke will be.

I continue around the first shape using a warm glaze similar to the warm underpainting on the left side of the sail. I begin the second sail shape by a negative glaze, and then begin a third.

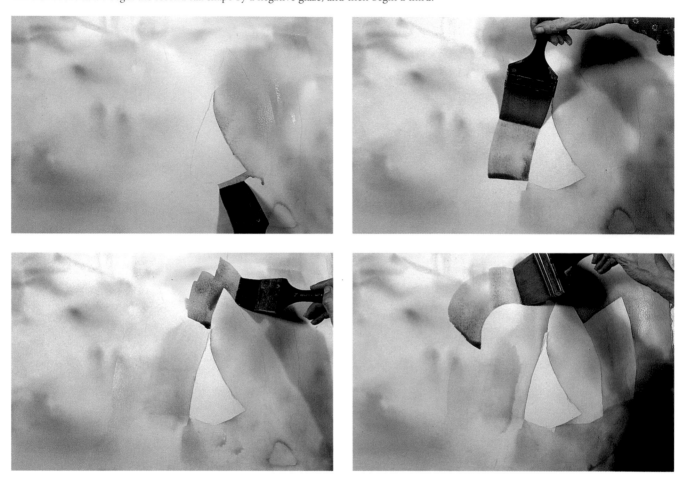

Now consider the disadvantage if you draw more than one shape at a time, as I have done here; it becomes technically quite difficult to proceed. It was easier to develop the painting one step at a time.

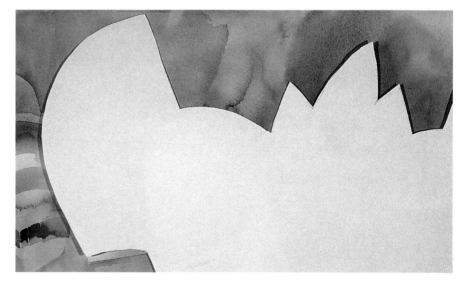

Defining Closely Valued Shapes

The edge of a shape is established by a value difference, even when it is slight. (Do not confuse edge of shape with outline. An outline divides areas by line.) To get a hard edge, of course, each time you glaze around a new shape, the paper must be dry.

Building up many layers is an excellent way to depict depth. A graded underwash will also alleviate the two-dimensional appearance that only one layer of glazing gives you. I use glaze colors that are similar to the underpainting to avoid a contrast that would emphasize the edge rather than the entire shape of each object. In wet-into-wet technique, several adjacent values can appear as one because the change is gradual. But when glazing, even slight value differences are easily distinguished.

There is a similarity of value within the matted areas; the purplish area on the right is somewhat darker.

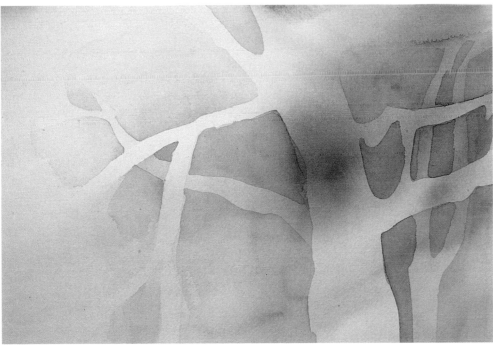

Because of the defining of the tree by negative glazing, the area enclosed by the glaze—even the purplish area—appears lighter than the value outside the shape.

Observe the subtle yet noticeable value difference between the areas with the transparent glaze layer and the unglazed areas. Had I not ended the glaze with a hard edge, the value change would not be readable.

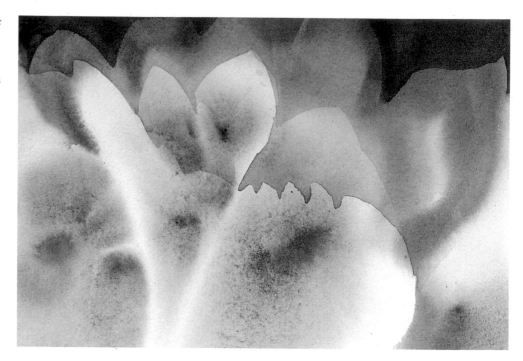

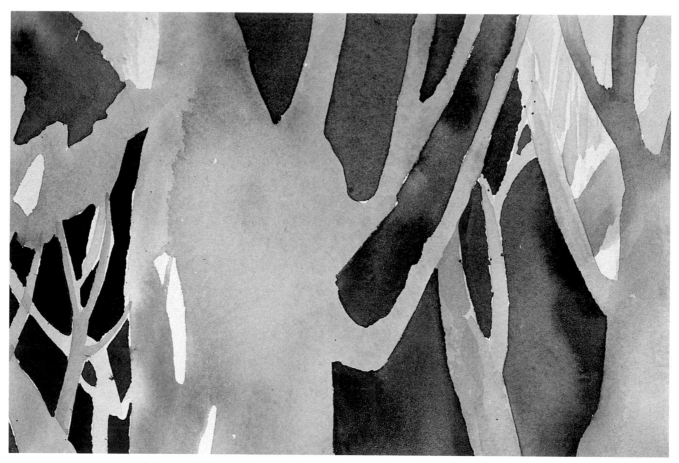

The large tree was "carved" from the underpainting, not painted directly. I used a layer of dark glaze to surround and delineate it and most of the smaller ones as well.

Carving Out Light Shapes

Values are always related to one another. If an area is to appear light, it must have something next to it that appears darker. The lightest tint of paint will not look as light as white paper. Although many artists wash out areas that are too dark, when I want to make an area appear lighter, I prefer to darken the surrounding area.

When a series of negative shapes are connected, the value within the shape always appears lighter than the value outside the shape, even when dark midtones are included as part of this shape. This lighter, negative shape is "carved" from the existing multivalued underpainting by adding a glaze that encloses and defines.

When I see a piece of color that resembles the shape of a leaf or other object, instead of allowing it to influence me, I assert my influence upon it. If it is a particularly appealing shape, I might use it, but I will put other colors adjacent to it together within a surrounding glaze. By doing that, I create a visual third dimension. Linking color and value changes within one shape eliminates the need for additional brush strokes, which may fragment the shape.

If you methodically adhere to the technique of negative glazing, just as I describe it, your paintings may result in being repetitive and stylized. If you vary it by your use of personal color choices in the underpainting, personal shape and content in subsequent layers, and in combination with other techniques, negative glazing can help you to see your subject matter in a new way. I suggest using this technique to restore an illusion of light without washing or scrubbing color away and to indicate light shapes without introducing positive shapes or line.

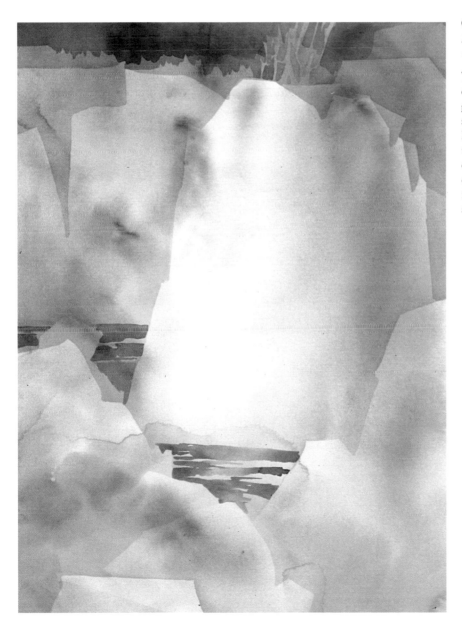

QUARRY
22 x 15" (55.9 x 38.1 cm).
Collection of the artist.

The monolithic shape in the center is composed of several colors and values in the graded underpainting. It was defined by a single negative glaze that combines the light left side with the shadowed right side, and these appear to be lighter than the areas outside the shape. It also looks three-dimensional because the underpainting grades from light to dark. Additional strokes to make shadows were not needed.

Pictorial Space

We see shape as it interrelates with other shapes in nature. Some objects, such as an airplane seen against the sky, appear to be isolated objects. We have all seen how children's perceptions lead them to leave a space between the sky and the ground in their art. There are no such spaces in nature. All things intermingle. When a painter ignores this reality and leaves spaces between shapes, "hourglassing" can occur. I use this term for the unpleasant left-out space between objects, such as the curved shape between two bottles.

In a grouping of objects, whether natural or artificial, only the object in front can be seen fully. In order to paint the way we see, it is logical to work from foreground to background, not the reverse, as is usually taught. I was taught to put the sky in first, to leave out the shapes that intersect it, such as rooftops, and to proceed downwards on the page. I ran into problems when I found a need for foreground for which I had not made provision. Painting shapes from foreground to background increases our awareness of proper perspective and scale.

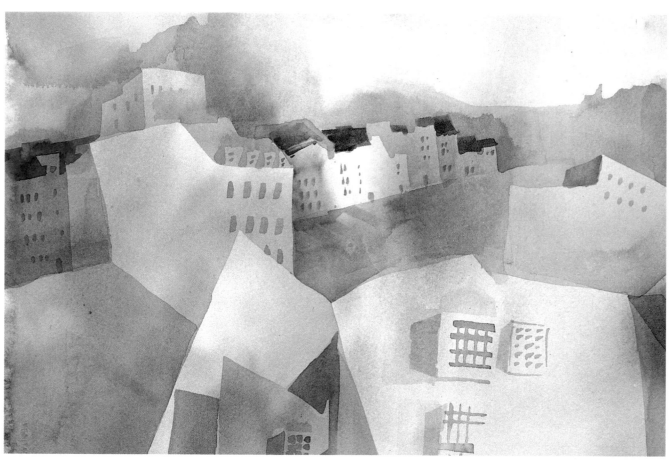

QUEBEC CONSTRUCTED
15 x 22" (38.1 x 55.9 cm). Collection of the artist.

I titled this painting to reflect my discovery that I had improperly loaded my film and my only reference was memory. But the construction of pictorial space from the process of underpainting and glazing, from foreground to background, is reflected also. The diagram at right shows the order in which the shapes were defined by negative glazing.

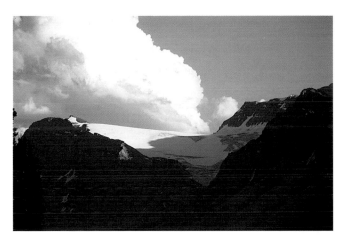

What value is white? This glacier at Banff, in Canada, caught my eye. Look how dark white can be when in shadow and yet still be white. Compare this photo with *Flowers with Blue*.

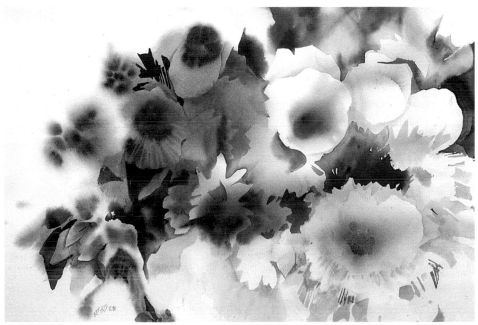

FLOWERS WITH BLUE
15 x 22" (38.1 x 55.9 cm). Collection of Roberta Carter Clark, Little Silver, New Jersey.

The negative glaze that describes the flowers in front (those that are not partially hidden) causes the other flowers to recede into the proper shadow tones.

Negative glazing can create illusions of great depth in small areas. Notice how the rock forms recede.

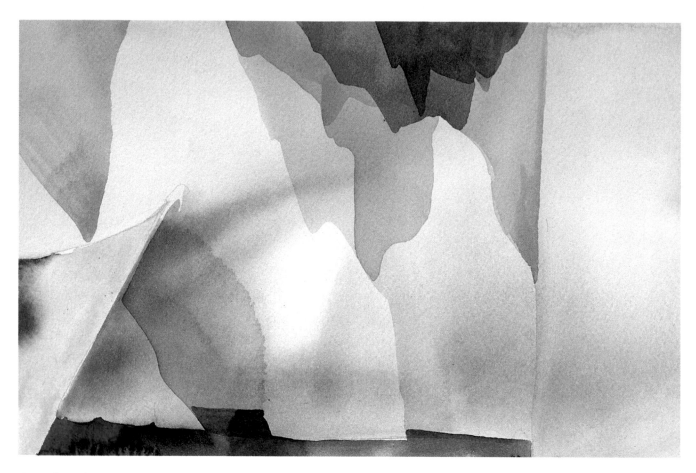

So much emphasis is placed on darks and lights in constructing paintings that the importance of a range of middle values is too often ignored. My favorite portion of this painting of cliffs is the one labelled 8 on the accompanying diagram of glazes: its shape and value provides the illusion that number 5 is three-dimensional.

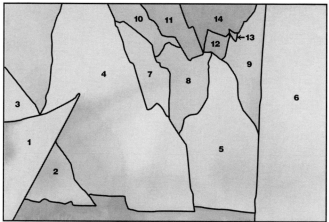

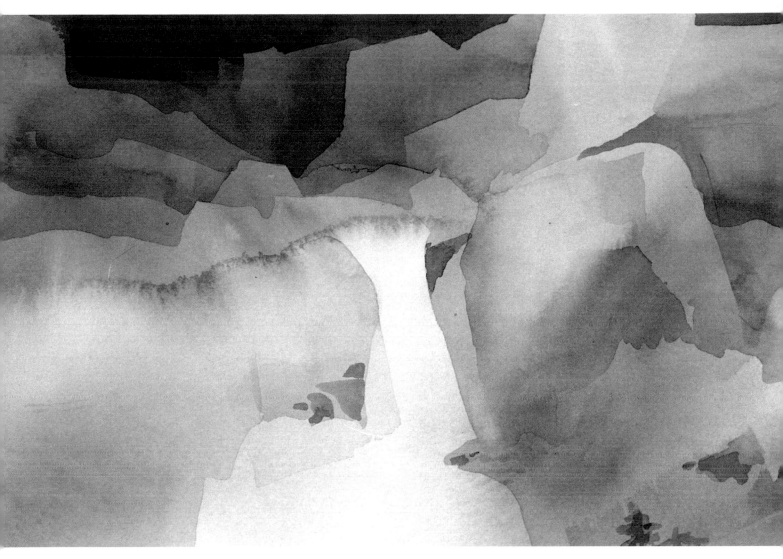

This painting began with an accidental shape, which became the top of the waterfall, then took on a life of its own. To avoid the monotony you can get from layers of parallel forms, I used negative glazes, tucking one layer behind another for variety. The white shape at the top that breaks the dark sky gives variety also, and the angles formed relate to the angle of the waterfall. Though I was taught that distant mountains are cooler and paler, reversing that maxim seems just as effective.

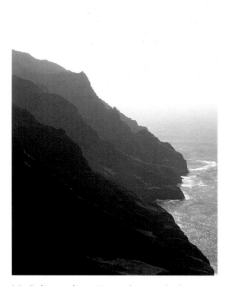

Na Pali coastline: Notice how each shape seems to be halfway in value between that of the shapes preceding and following it. This gradation creates an illusion of depth.

Layered shapes: Turn this illustration upside-down, and it will appear to be an example of negative glazing.

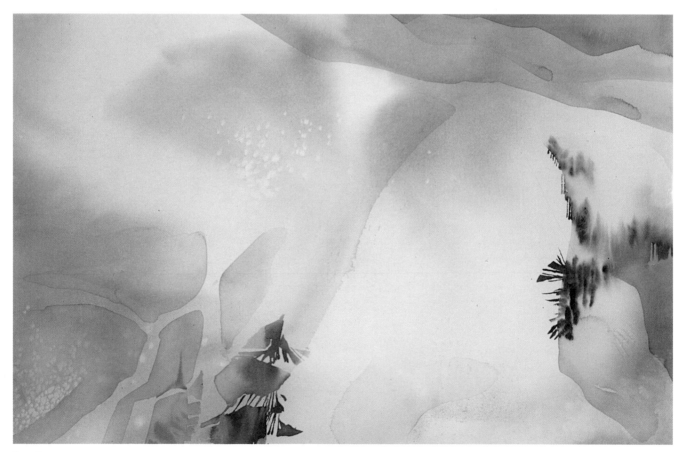

SKI COUNTRY
15 x 22" (38.1 x 55.9 cm). Collection of the artist.

There are relatively fewer glazes in this composition, yet they render the spatial depth that turns it into a mountain vista.

Painting Backgrounds Last

When depicting light objects such as buildings, flowers, or boats, painters sometimes differentiate the edges of those shapes with line. Clearly, this does not portray nature accurately. Negative glazing can render shapes into the proper value for their receding into the background or into shadow. In my early paintings where I used frisket or left out the whites to attend to later, there would be unnatural "unpainted holes" that disrupted the flow of the painting, so I developed my more continuous approach.

Putting in the background before painting the subject is like choosing accessories before you know what you want to wear. The addition of sky or background last makes it easier to choose the proper color, value, and mood to enhance the content. Although it is difficult to fit a background behind an intricate pattern of branches,

I have found two foolproof methods of doing so with relative ease. I prefer these methods to using frisket for saving light. When the background is to be lighter than the subject I rewet the entire painting or an area that extends well beyond the area I need to paint. I look for a previously painted edge within this area as a natural place to end the water shape, then apply a new glaze of the light background color. This glaze disappears into the subject.

If I prefer a darker background, I use darker paint to form a new silhouette. Most painters find it very difficult to abut two shapes perfectly without getting a hairline of overlapping pigment or a hairline of space between the shapes. I avoid seams by overpainting edges so that the overlapped area acquires a new contour.

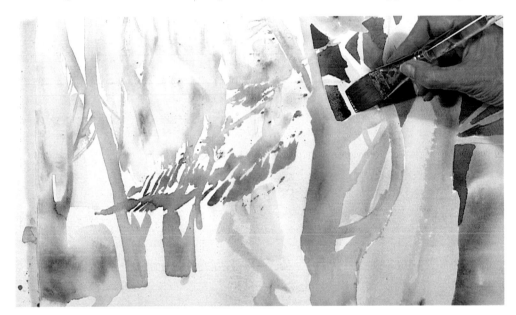

I have not tried to fill in the white background up to the edges of the tree trunks. The dark shapes I add here negatively suggest branches. Some of the dark tones cover parts of the existing light-colored trees, cleaning up edges and improving contours.

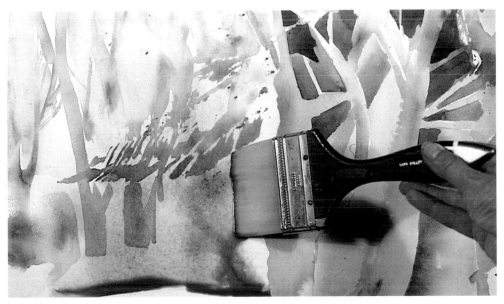

I have washed a light background right over the trees, rather than trying to fill in the space around them.

6 WET-INTO-WET TECHNIQUE

At one time or another every watercolorist will wet all or a portion of a piece of paper and will then apply paint. I remember playing with wet paper when I was first taking painting classes, in addition to completing the assigned exercises. I was taught to limit the use of soft edges to depicting clouds, skies, backgrounds, or snow, and perhaps to vary the edge of a primarily hard-edged shape. Wet-into-wet is fun, they said, but not to be taken very seriously.

I rapidly became enamored of this technique, however. I favored the unpredictable effects of pigment flowing into wet paper and enjoyed making use of the accidents and working without preconceptions.

> In order to paint one has to go by the way one does not know. Art is like turning corners; one never knows what is around the corner until one has made the turn.
>
> –MILTON AVERY

Although wet-into-wet represents only a portion of my work today, the love affair continues. The soft-edged shapes provide the poetry and mystery in many of my flower, landscape, and abstract paintings.

My instructors in wet-into-wet technique required me to sponge thoroughly both sides of the paper until it was limp, and to prop its support board at an angle prior to painting. As I have already indicated, I completely abandoned this practice, which tends to remove the sizing from the paper. Instead, I gently wet one side of the paper surface with a large synthetic wash brush so as not to agitate the paper surface in any way. Then I tip the paper to allow the excess water to drain from it. Alternatively, I may immerse the sheet in a tub of water. Both procedures ensure an undisturbed surface with the sizing intact. The advantage of this method is that paint applied to sized paper produces lovely spurting effects which can provide ideas for subject matter.

Also, the sizing creates a barrier so that if my initial strokes of color are unfortunate choices I can quickly wash them away with the squirt of a hose. Even the highly staining colors can be removed this way. But if the sizing has been sponged away, the paint will instantly soak into the paper. Effects can still be achieved on unsized paper because the surface water will soon dissolve the remaining sizing. Once the paper is evenly wet, I place it on a flat surface so that the shapes I paint will not spread downwards, as will happen with propped paper. (Again, I have found Arches 140-lb. cold-pressed paper to be a particularly receptive surface for this method.)

Sap green and aureolin yellow have been painted onto wet paper four times, each time with another step added.

The second example adds a touch
of permanent magenta.

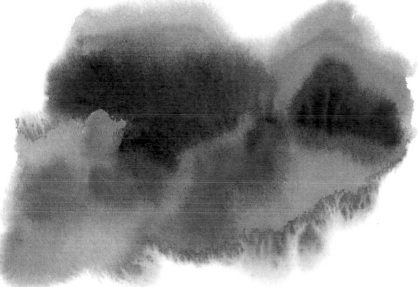

The third example adds burnt siena
to the first three colors.

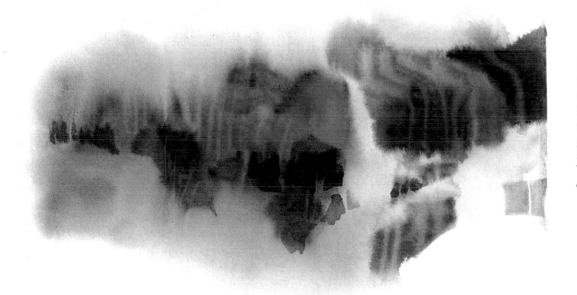

Like a telephone doodle, the
initial shape grows as pigment
is added. Finally, I drew thin
lines with clear water when
the paper was only damp. I
put in the hard-edged rock
forms once the paper was dry.
The light green at the center
could become a waterfall.

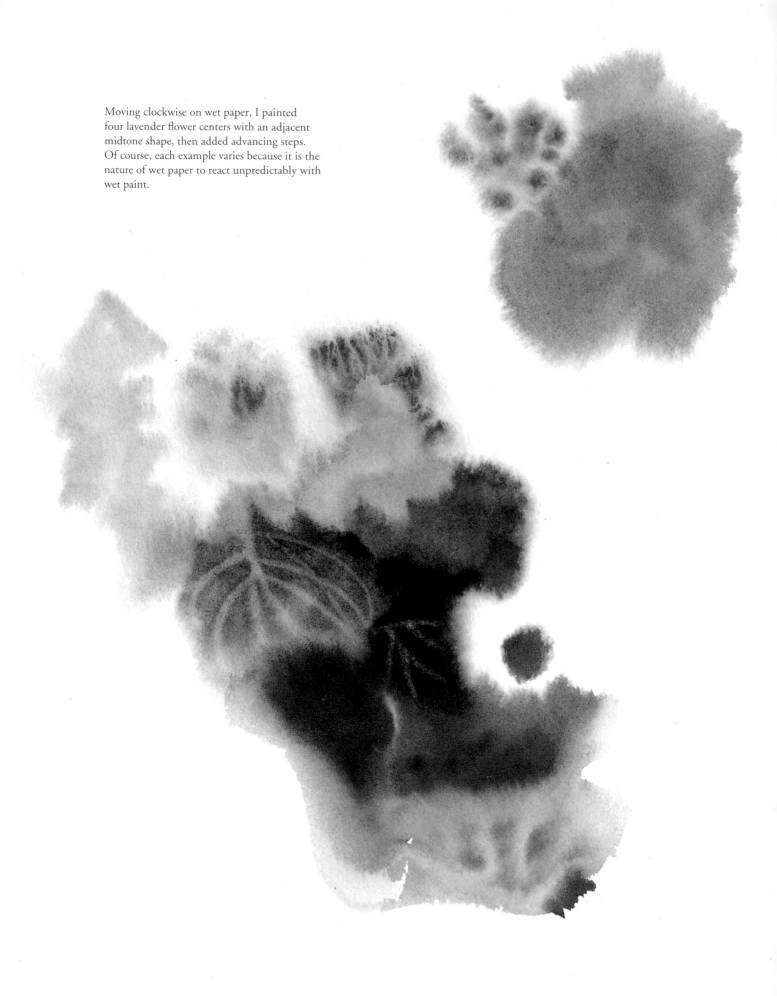

Moving clockwise on wet paper, I painted
four lavender flower centers with an adjacent
midtone shape, then added advancing steps.
Of course, each example varies because it is the
nature of wet paper to react unpredictably with
wet paint.

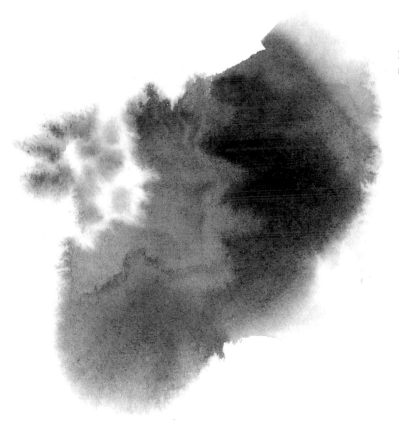

In the second example, I carved into the midtone with a darker shape to form petals.

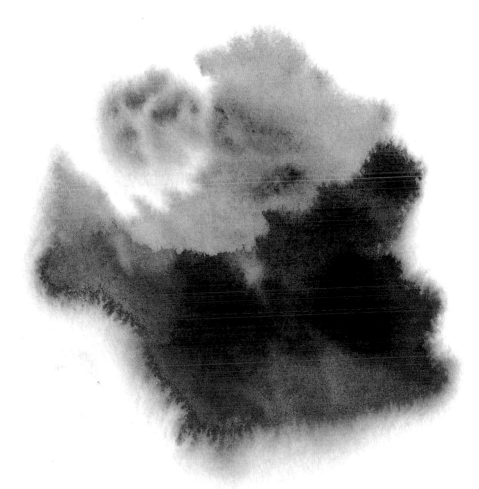

In the third and fourth examples, the addition of shapes adds interest.

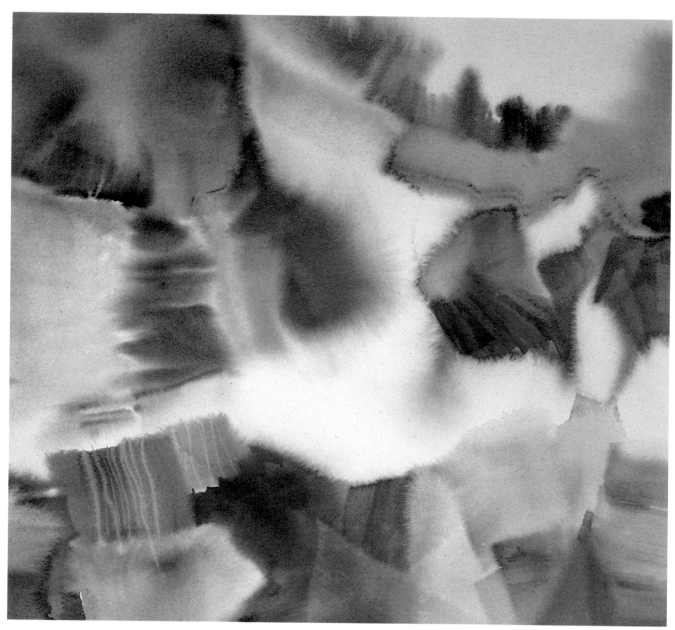

Wet-into-wet underpainting of abstract landscape forms: soft edges
are defined by abutting shapes of a different color or value.

Consistency of Water and Pigment

Opaque and semi-opaque colors hold shape better than transparent colors. If a brush stroke includes some opaque pigment, control is more easily maintained. To control my wet shapes, even if I prefer the color of a particular transparent or staining color, I will add some opaque color to it.

Instead of memorizing color formulas or the properties of each color, I set up my palette and load my brush in a way that easily gives me the needed colors. With all the colors of one family side by side, I dip my brush into three or four to end up with the color closest to my choice. The odds are that the brush will contain both transparent and opaque color.

When the paint is released onto the wet paper it will have both the dominant color I seek and the properties I need. It is also easier to see the color temperatures when they line up on the palette this way. I can instantly pick out a cooler blue, such as Prussian, or a warmer blue, such as ultramarine, when these two are next to each other—whereas any blue placed next to red or yellow will appear cool.

The first shape placed on wet paper will bleed at its edge more than desired. When a second shape abuts or overlaps it, the bleeding stops. Students are usually afraid to place a second shape next to the first, for fear the colors will spread into each other and mix. In fact, the two adjacent wet shapes act as a barrier to each other. Shapes will, of course, spread into a space that is allowed to occur between them,

but any so-called hourglass shape that results between them will be difficult to incorporate into a workable design.

Since the unpainted part of the paper dries faster than the part that has a layer of paint on it, I build shapes consecutively; this means that, essentially, I work with one continuous wet area and avoid having drying areas between wet shapes. This makes it easier to rewet the unpainted areas. Painting in this way is also an aid to good design: each shape made "tells" what the next needs to be—bigger, smaller, lighter, darker, brighter, grayer.

Although paint applied to wet paper will dry lighter, if value relationships are considered side by side, the relationships will still be consistent when dry. (I add an extra stroke of pigment to each to compensate for the lightening.) I usually place as many as four different values adjacent to each other.

If a value appears to be too light, it is risky to add pigment unless the area is still quite wet. A brush applied to a damp area risks imprinting its stroke with a *crawl-back,* a bleed that occurs when a damp area collides with a thoroughly wet area. However, a spatter of pigment from a toothbrush (without much water added) will give you the needed value. Conversely, if a value is too dark, I draw fine lines with a rigger brush and clear water when the shape is at the damp stage; that way, the value becomes less prominent. Although the new linear texture is noticeable, I draw lines that are consistent with my subject, such as leaf veins, rivulets on a beach, or rows of crops in a field.

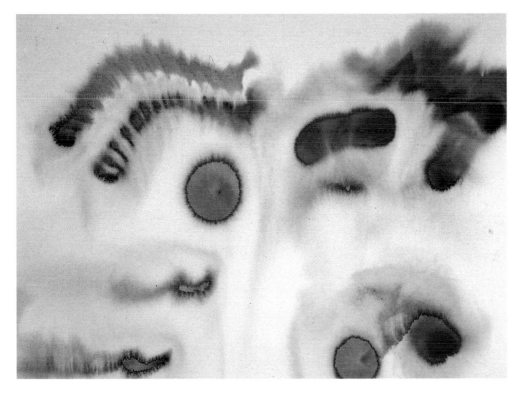

In wet-into-wet, spurts of paint separated by blank spaces have less definition at their edges.

These abutting, or consecutive,
shapes hold their form.

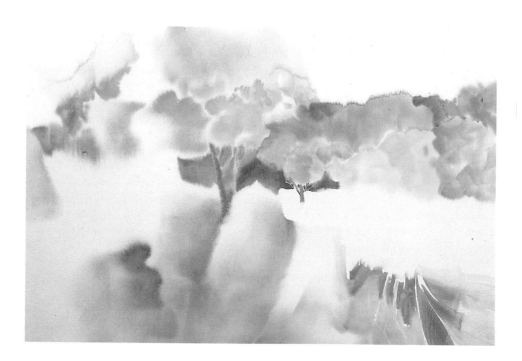

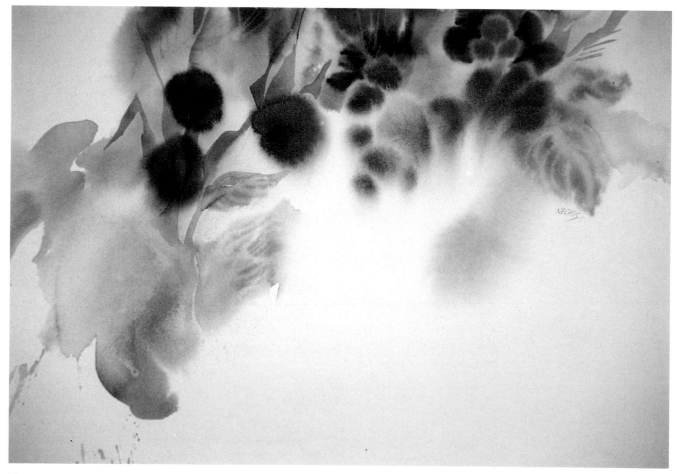

NEW VINTAGE
15 x 22" (38.1 x 55.9 cm). Collection of the artist.

I began at the top right and worked each shape consecutively, ending at the left as the paper began to
dry. The idea is harvest, but the subject is ambiguous, and the viewer must complete the painting. It
could be of berries, flowers, or just shapes found in nature and placed next to each other.

Rewetting Paper for Consistent Soft Edges

Paper that is only surface-wet will quickly dry. When large papers are being used, no wetting method is sufficient to keep the paper wet long enough to complete a painting, so one or more rewettings may be necessary.

The easiest way to rewet paper is to immerse it briefly in water after it has thoroughly dried. Although a slight amount of pigment may run, this will be consistent with the wet shapes already painted.

If you do not wish to rewet the whole paper, it can be partially rewet, but care must be taken so that seams are not visible between the old and newly wet areas. Only if the painted area is still quite wet can the dry area be rewet so that the two areas will blend together without a problem.

In order to sustain the wet-into-wet look and avoid a crawl-back into the previously painted area, it must be thoroughly dry before rewetting. I rewet, with a clean brush and clean water, both the unpainted area and enough of the painted part so that when pigment is placed on the new area it will not run as far as the edge of water. If the edge of water in the painted part is blotted with a tissue, it will not be visible.

Immersing a painting that has dried barely disturbs the pigment.

My favorite spot as I begin this painting is the green curling leaf edge at the lower left, an illusion created in a single stroke of wet paint. I stopped painting at this point because I wanted time to think of how to finish.

Later, I immersed the painting for a few minutes so the unpainted areas could be finished in the same way the painted areas were. Can you find a demarcation between the finished painting (below) and the unfinished one (right)?

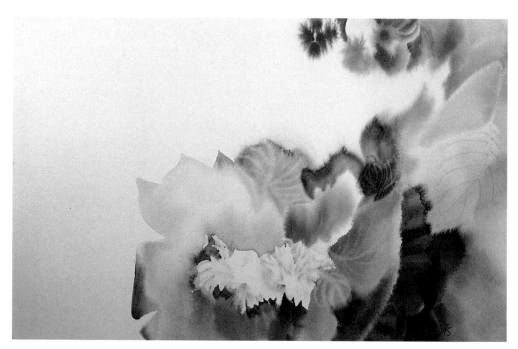

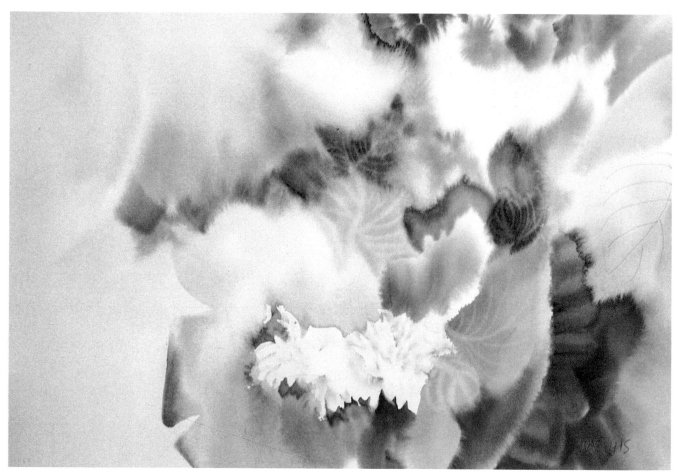

TAPESTRY
15 x 22" (38.1 x 55.9 cm). Collection of the artist.

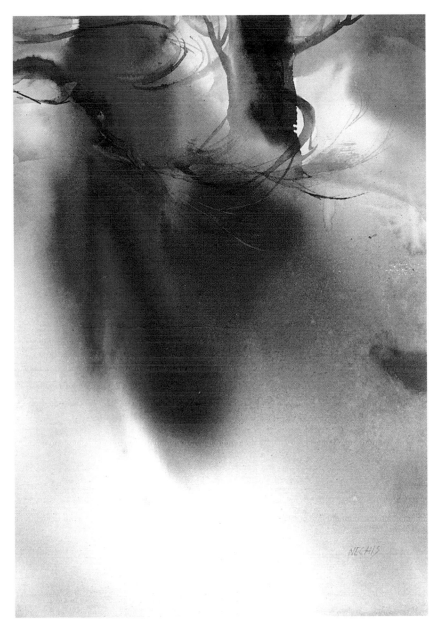

DEEP PURPLE
12 x 8" (30.5 x 23.3 cm).
Collection of Elsie Cohen, Calistoga, California.

A lot of pigment was added to the dominant wet-into-wet shape to compensate for the lightening of it during drying. The hard edges were painted once the paper was dry.

Here, I emphasized the crawl-back edge by painting up to that edge with negative-glazed mountain shapes. Subtle effects such as this one can add mystery to a painting.

Taking Advantage of Crawl-Backs

Sometimes, by accident, I will produce a crawl-back, and sometimes I will cause one to occur deliberately. This type of wet edge is appropriate for depicting a flower, a leaf, a cloud, or even a snowcap on a mountain. If the edge is accidental, I incorporate it so that it does not appear so. Arbitrary "crawls," with the addition of veins, become leaves, and flower centers can be introduced so that an accompanying crawl becomes the petals' edge. In making this kind of edge on purpose, I put a rewetting brush stroke next to a still-damp painted area, making sure that the result is a useful shape, rather than an arbitrary one.

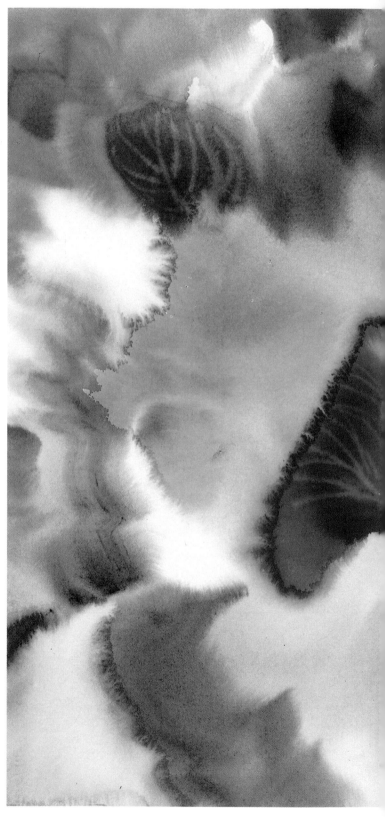

MOTHER OF PEARL
15 x 22" (38.1 x 55.9 cm).
Courtesy of The Artful Eye Gallery,
Calistoga, California.

The strong red abstract shape, with its poetic crawl-back edge, makes this flower painting a little different.

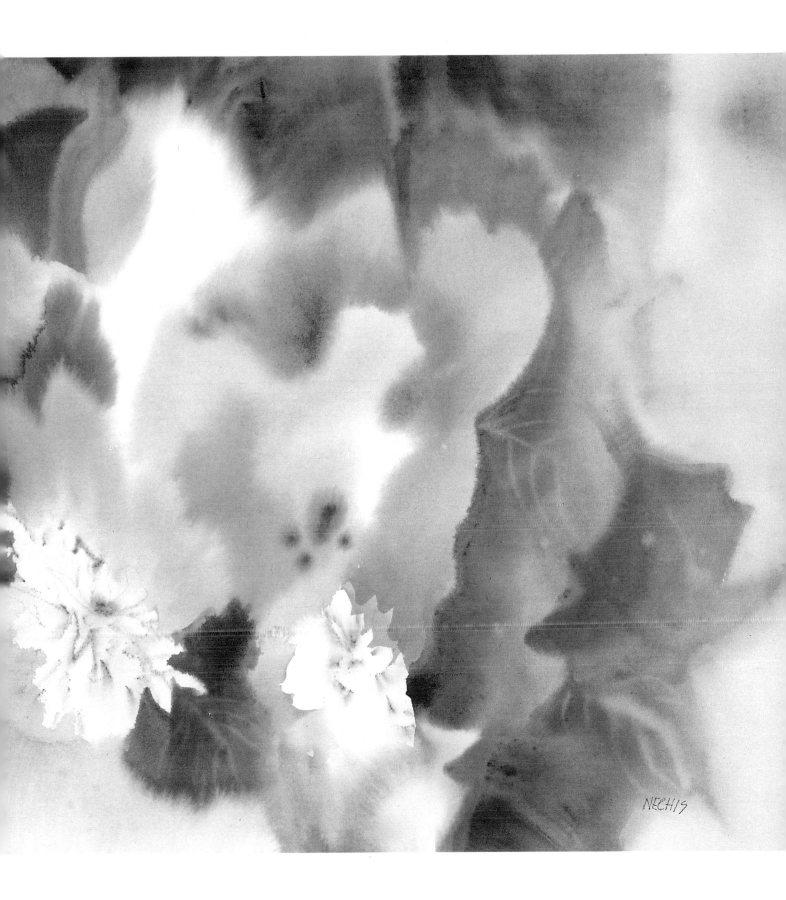

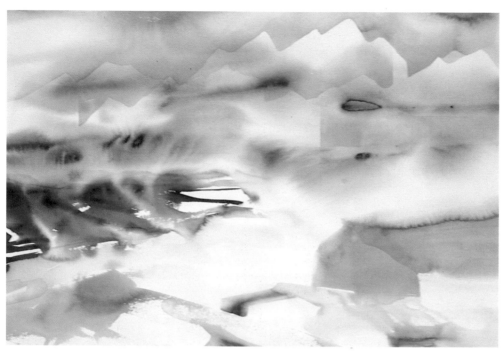

I was intrigued by the crawl edge in the underpainting at the top of the lower right quadrant. I developed it into a wave by painting rock forms beneath it. The strength of color and pattern in the finished painting (right) represent my response to the overwhelming forces of nature in the Canadian Rockies.

BLUE JASPER
22 x 30" (55.9 x 76.2 cm).
Collection of Barbara and Dr. Chahin Chahbazian.

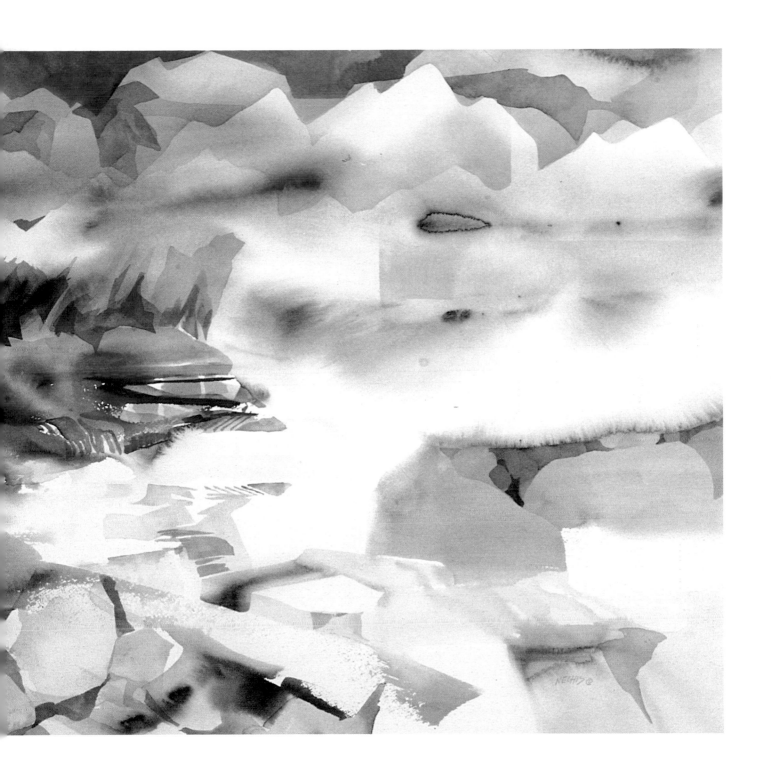

Combining Watercolor and Gouache

A useful watercolor variation employs the gouache medium. I began using opaque white gouache to lighten overworked paintings, but when I discovered its use as a color extender rather than a value corrector, I avidly made it an adjunct to watercolor in my work.

I frequently purchase colors new to me because any means of breaking habits tends to introduce new interest into the picture-making process. White gouache, when mixed with ordinary watercolor pigments, gives a completely new range of paints. There is a subtlety in the variations to be achieved by mixing white, rather than water, to lighten a color. My need to explore another medium is satisfied. Some of the pearl colors, such as Holbein's Pearl White, Pearl Copper, and Pearl Gold, are additives that strike color chords unattainable in transparent watercolor.

There is a product on the market, made by Holbein, called Acryla Gouache that *will ruin your watercolors and brushes if you combine it with them.* It looks like gouache when dry, but it is an acrylic product. Do not confuse it with gouache!

The properties of gouache are slightly different from those of watercolor. Gouache dries a little darker, a distinct difference, but it reacts similarly when used for wet-into-wet painting. It does not undergo chemical change when dry, as does acrylic, so it can be washed out and reworked in the same way as pure watercolor.

Avoid leaving gouache on your palette beyond the painting period; it solidifies when in concentrated form and becomes difficult to remove. You can squirt the amount you plan to use for a painting session in the center of your palette. Dip your brush first into watercolor and then pull it to the gouache for mixing. Having the gouache in the center will remind you to mix each stroke with it before applying brush to paper. That way you will maintain consistency.

Naturally, if all the colors used are mixed with white gouache, dark values will be unattainable. I usually work in a more limited value range when I use gouache, but I compensate by using more color. The white, when mixed with each of the colors, becomes a unifier. Occasionally I will add transparent dark if I want stronger value contrast.

When your brush goes back and forth among the colors, gouache easily contaminates watercolor fresh from the tube. For this reason, I tend to put gouache on my palette when it needs a refill of pigment. At the end of the painting session, I carefully lift any residual gouache from the tops of my paints using a clean brush and water. If I miss a little residue, it does no harm to future work.

JEWEL
*Watercolor and gouache on paper, 15 x 22"
(38.1 x 55.9 cm).
Collection of the artist.*

Pearl white and copper gouache added to watercolor gave me new color combinations. The jewel, pure blue and magenta, intensifies amid the surrounding subtle colors.

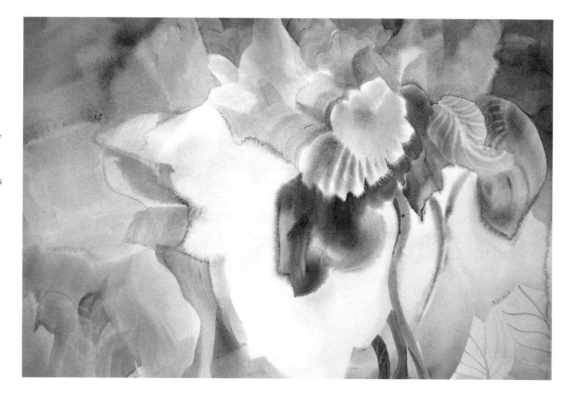

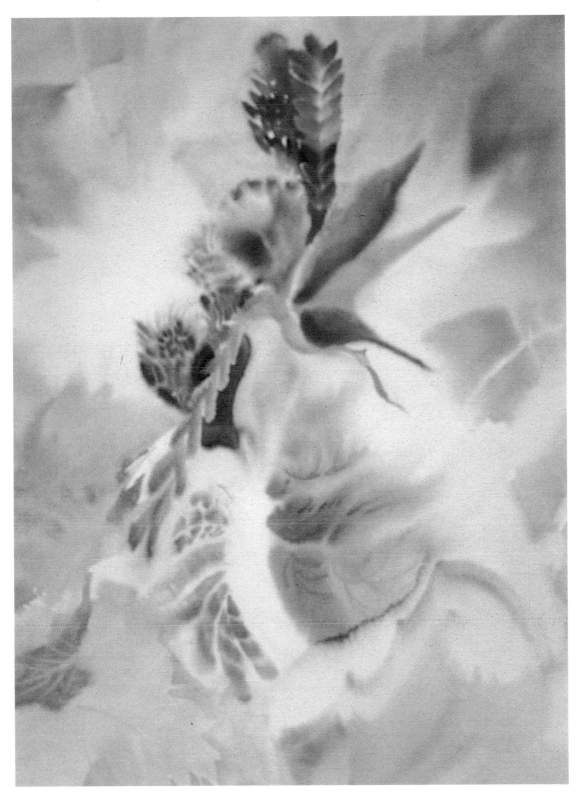

IT'S NOT GINGER
30 x 22" (76.2 x 55.9cm).
Courtesy of F. Dorian Gallery, San Francisco, California.

Because a Bird of Paradise is bright red, gouache is an unusual choice here,
for gouache softens the effect.

Water-Soluble Crayon and Pencil

Crayon and pencil add a linear quality to your work. Using them in combination with flowing watercolors, I render them compatible with the wet-into-wet look, rather than allowing their linear quality to contrast with it. I encourage linear bleeds by dipping the crayon or pencil in water before using it on wet paper. This avoids rough crayon or pencil lines, and the resultant lines are fluid, even spurting. Crayon can cause difficulty when used on wet paper because it repels water, causing dry spots to form. Notice the hard edge surrounding the crayon petals in *Chrysalis*. I often add glazes so that the hard edges caused by the repelled water are not the sole hard edges in the painting.

CABBAGES, ET CETERA
15 x 22" (38.1 x 55.9 cm).
Collection of the artist.

Here, crayon dipped in water was applied to wet paper. My garden was the source.

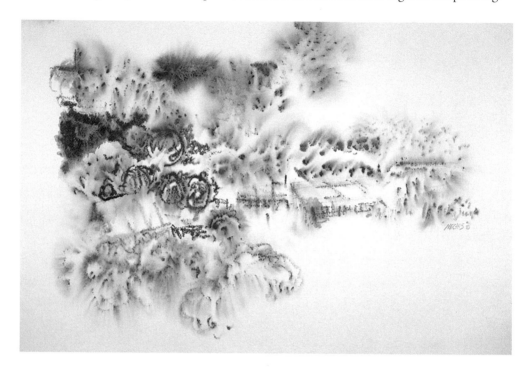

FLYING CARPET
Gouache, watercolor, and crayon on paper. 15 x 22"
(38.1 x 55.9 cm).
Collection of the artist.

I began with water-soluble crayon shapes and added the larger gouache shapes. The idea was inspired by the rich patterns of rugs I saw in Santa Fe, New Mexico.

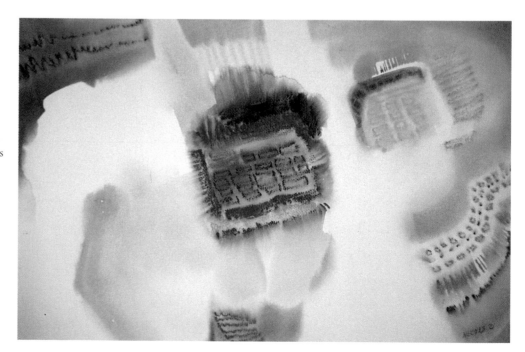

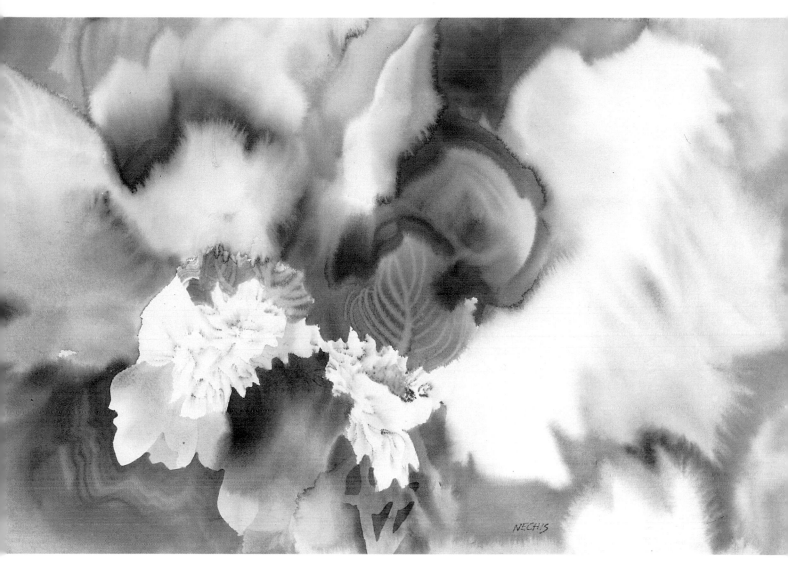

CHRYSALIS
15 x 22" (38.1 x 55.9 cm). Collection of the artist.

By using water-soluble crayon line on wet paper, I was able to produce a rhythm that I repeated in the larger and simpler floral or wing shapes, painted wet-into-wet. Ambiguity often makes the viewer pay attention, as do subjects painted larger than life. By using a fine brush and clear water, I drew the negative lines of the leaf veins when those areas reached the damp stage.

INVENTIVE DESIGN

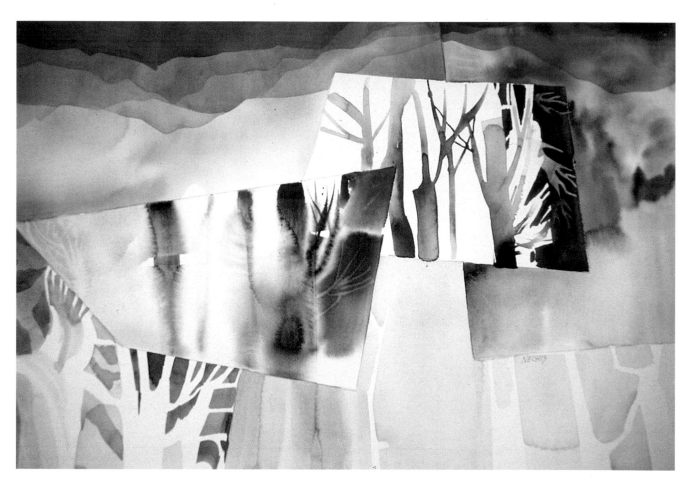

QUILTED WOOD
15 x 22" (38.1 x 55.9 cm). Collection of the artist.

*T*HE PRINCIPLES OF GOOD DESIGN are a lot like the principles of living. Perhaps you can pattern yourself after someone else, but it is the individuals and paintings that are true to themselves that really succeed. ❦ When you think of principles of good design, try to avoid thinking about hard-and-fast rules, on the one hand, and falling back repeatedly on yesterday's successful experiments, on the other. Be a seeker of strong, well-thought-out design, *and* be inventive and remain flexible in your thinking. ❦ I use many teaching tools to help students consider design elements from the first to the last stroke of each painting. One approach, patterning, is an excellent basis for a strong design. As you experiment with patterning and other methods of building a painting, allow your work in progress to provide you with design ideas. Use your intuition to discover where you are succeeding and where you need to make corrections. The creative thought process essential to the most inventive of designs is identical to that needed for a successful traditional painting. ❦ "Design and composition," wrote the photographer Paul Strand, ". . . are not in themselves a static prescription by which you can make . . . anything which has meaning. They signify merely the way of simplification and synthesis which creative individuals have found for themselves." ❦ Helen Frankenthaler, the great abstract expressionist, also understands this. Keeping in mind well-considered ideas of what she might do in a painting, she simultaneously keeps herself open and undecided: "Both feelings operate at once," she said. "They give me direction, purpose, and freedom to be myself, and I proceed from there. If everything goes right, my own truth will come out beautifully."

The human tendency toward the fossilizing of form is shocking. . . . Yesterday the man who exhibited a new form was condemned. Today the same form has become immovable law for all time.

—WASSILY KANDINSKY

7 DESIGN CONSIDERATIONS

I caution you not to use the following list of design considerations rigidly. Instead, use it as an aid when you need advice. Most of the following considerations are universal, but you should use them not to design your paintings but rather afterward, to critique problem paintings and learn from them. If a painting pleases you, there is no need to critique it. If you are puzzled that it pleases no one else, and you think you can improve it, then the checklist below may be useful. I have deliberately listed questions to consider, not rules; even so, some of the questions in the checklist cannot be applied to some of the world's greatest works of art.

As you work, hold these precepts in the back, rather than the forefront, of your mind, and allow the content of the work and its reason for being to shine forth, unhampered by restrictions.

Design Checklist

Content

☐ Does it have meaning?

☐ Is it interesting or worth painting?

☐ Is the quality unique to you?

☐ Does it have an element of surprise in its mood, color, shape? Is this the wow! or the why it was painted?

☐ Does the world need another picture of _____ ? (Fill in your own term and ask yourself how you can make this one say something new about the topic.)

Shapes

☐ Is there some predominant pattern of shapes: curvilinear, angular, or straight? Is there a dominance of horizontals, verticals, or obliques?

☐ Do the shapes work well with the shape of paper being used?

☐ Are the shapes simple and straightforward? Do they need interest within them or at their edges?

☐ Is there a connection or linkage from shape to shape?

☐ Does the viewer know where to look?

Space

☐ Are there large areas and small areas?

☐ Are there areas of detail and interest?

☐ Are all parts of the paper considered—main, supporting, and rest areas?

☐ Is the subject scaled correctly for the shape and size of the paper?

Colors

☐ Is there a dominance of either warm or cool colors?

☐ Is there enough color change or interest?

☐ Are there enough neutrals to "show off the color"?

☐ Is the color thoughtfully placed?

☐ Is it interesting or a cliché?

Values

☐ Are the values easy to read?

☐ Can shapes be distinguished because values in adjoining shapes are varied?

☐ Are the light and dark value patterns pleasing?

☐ Do they allow or encourage you to look at the important parts of the painting and move through it logically?

☐ Are values chosen to emphasize or diminish interest, where appropriate?

Superimposing Pattern for Better Design

Developing grid paintings—I use the term *grid* for superimposed pattern, divisions of space, and the fragmentation of shape—can help you think about shape in a way that should strengthen your designs when they are *not* based on the grid. The grid method can help to reinforce the thought process in designing, which sometimes gets neglected in more traditional painting.

Use of the grid is rooted in the art of ancient Mediterranean civilizations. It was adopted by and incorporated into the Cubist works of Picasso and Braque and the similarly geometrical works of Charles Demuth. Elements of it are apparent in works in my collection by Nanci Blair Closson, Marylyn Dintenfass, and Merle Perlmutter. As their art shows, it is easy to incorporate pattern into many kinds of work without allowing it to diminish variety or to overpower personal style. I use it to express familiar content in new ways. Some subject matter, such as boats, the crockery in still lifes, and farmland, which can resemble a patchwork quilt, is easily adapted to sectional divisions.

Superimposing pattern plays an important part in expanding content and strengthening a natural use of design elements in my work. I have been superimposing pattern for more than a decade and will continue to do so periodically, but each time I do, I seem to produce markedly different types of paintings. The following examples show the evolution of the changes in my grid-based work. When I began to explore this approach, I neither invented it nor sought to devise lessons: I made my first grid painting by accident when I was trying to reclaim discarded work. Each succeeding group of paintings evolved as I tried to solve problems I had created in the preceding paintings. By imposing artificial space divisions, I can find new solutions to design challenges, but what I learned from using the grid approach has expanded my design concepts far beyond the initial purpose of the idea.

Merle Perlmutter
ASCENDING MEMORIES, DIMINISHING DREAMS
Etching intaglio. 26 x 18" (66 x 45.7 cm). Collection of the New York Public Library, Miriam and Ira D. Wallach Division of Art, Prints and Photographs. Photograph by Ira Wunder, White Plains, N.Y.

Perlmutter's works are masterful arrangements of interior space, reflecting Cubist designs.

Nanci Blair Closson
WINDOWS
Watercolor and ink on paper, 30 x 22" (76.2 x 55.9 cm).
Collection of Barbara Nechis.

I have owned this painting for a dozen years and see new
things in it all the time. Recently I realized its relationship
to my own teaching about divisions of space.

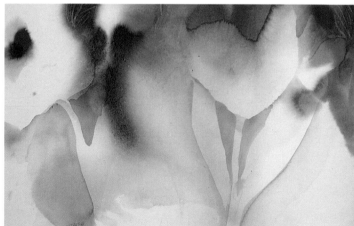

RED QUAD
Each panel 15 x 22" (38.1 x 55.9 cm). Collection of the artist.

All four panels were painted within one month, but without thought of combining them, so
there are accidental, slight color differences between them. I have since made a practice of
consciously incorporating color differences such as these in multi-image works.

Putting Separate Paintings Together

Framing and hanging several paintings to form a unit can be an excellent way to build large works without facing the logistical problems caused by working on one large piece of paper. A multiple-image piece can suggest many things. It can be a progression or a process, such as a subject moving in space, changing in shape, becoming larger or smaller, emerging, or disappearing. It can be separate paintings with a single linking shape constructed by the addition of a layer of glaze. It can be composed of any number of parts which interlock to create a total landscape or abstract. The parts can be framed separately, or mounted in a single mat with separate windows.

You will have to make decisions concerning the space between sections. A curved line will appear continuous if matless sections are placed close together. If larger space between sections is planned, perhaps to accommodate matting, a continuous line will not only be broken, but it will lose its original contour, unless some compensation for the space is introduced. The same considerations must be applied to shapes.

The work must come together as a whole design, but it is essential that the individual parts constitute complete, separate entities as well as parts of the whole. Otherwise, the effect of the whole is weakened, because the separation of the parts emphasizes weak areas. In larger works it is even more important that each part say something different from its neighboring piece. Otherwise, the sections will be redundant.

In *Red Quad,* I introduced a color difference into each part: a warm green in the first, a cooler green in the last.

Neither green appears in the other sections. The orange changes from a yellowish shade in part one to a true orange in part four. Even though each of the parts is a distinctly separate painting, both the subject matter and the dominance of curved shapes in them all serve as links.

When you put paintings together, guard against two common problems in multiple-image work. The first is any obvious indication that you arbitrarily cut and framed one painting as several. In many I have seen, rarely was there a good reason for the placement of the cut other than that it was dictated by the frame size.

Equally displeasing is a grouping which consists of two paintings which hold together fairly well individually, but which sandwich an insubstantial painting designed solely to link them together. I have fallen into this trap, but have since learned how to avoid it. My usual method of putting multiple paintings together to form a larger work is to select a group of completed or nearly completed paintings that are close in subject, color, and mood. Since I usually focus on a series of related pieces, influenced by one idea or experience, it is not difficult for me to make a group work as a single unit. I may examine a dozen such pieces and select from these a few that meet my requirements. Then, if I need to paint a new section as a link, I do not allow the group selected to overinfluence my new painting. Instead, I place a few pencil lines to indicate where a shape might continue, to relate the new section to its neighbors. I then complete the painting without looking at its companions. When all the parts are finished, I usually strengthen the unity by adding a few linking strokes, if needed.

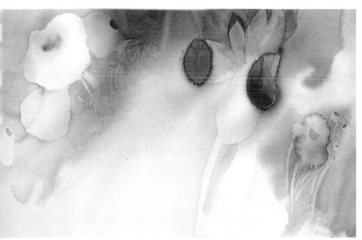

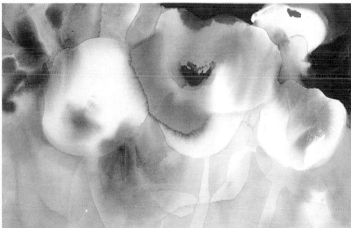

Cutting and Reassembling Paintings

I started experimenting with pattern by selecting salvageable portions of failed paintings, then cutting them and placing the mini-paintings together within a large frame.

To create *Fog City* I cut a 22 x 30" painting into 5 x 7" sections. Selecting six that worked together, I found a form that lent badly needed interest.

Earth Forms contains some connection of shape where sections abut. I cut the parts from several discarded paintings and painted additional shapes to make it cohesive. I have hundreds of sections chosen from failed paintings waiting to become parts of another whole.

FOG CITY
16 x 15" (40.6 x 38.1 cm). Collection of the artist.

In its original form, the painting's only merit was unity of color and shape; otherwise, it was boring because of repetition and too little variety. I was able to suggest a disappearing and re-emerging city by cutting and reassembling it.

EARTH FORMS
16 x 22" (40.6 x 55.9 cm). Collection of Jane and Alexander Petruska, New Rochelle, New York.

The two upper-right sections were cut from one painting, the two lower-left ones from another. The upper-left, the middle-right, and the lower-right panels came from different paintings. I painted the middle and middle-left panels to complete the whole.

Masking Tape as a Design Tool

Because I have had difficulty choosing among the endless possibilities of arranging separate pieces or paintings, I began to use masking tape to divide the space on a piece of paper. My paintings using tape have been of two types. In the first type, I emphasized the separateness of the sections. A visit to a new place might cause me to select a variety of subjects representing that place. I would combine them in the same painting, with the tape creating the divisions. In the second type, I arbitrarily placed the tape in random strips, making divisions that pleased me, and painted a single painting.

When I used drafting tape to divide my paper into sections, I wanted each section to work alone and in conjunction with others as in the groupings of cut-up paintings. As I explored the new procedure further, I found

it an aid to good design. The repetition of the taped shapes could be useful in combining more diverse subject matter than a traditional painting has, because even when the subjects had few shapes in common, the tape line provided the needed repetition.

You must paint up to the edge of the tape on at least one side of each tape strip, or the grid pattern will be lost. However, leaving some white space adjacent to some of the taped areas will prevent the tape from forming white frames that separate the sections too much. I prefer to paint up to one side of a piece of tape and bring my stroke outward elsewhere, so that the taped space becomes irregular. I also learned to remove the tape earlier in the painting process and then to paint over some of the previously taped area so that those areas would be better integrated.

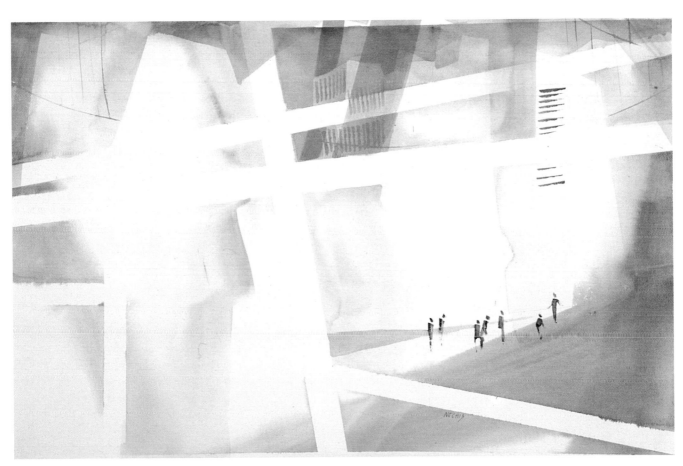

CITY SEEN
15 x 22" (38.1 x 55.9 cm). Collection of the artist.

The placement of the masking tape was arbitrary. I just made a pleasing design, then began painting without a subject in mind. The city seemed to emerge. I think of the angled taped pieces as girders through which we look to see the city.

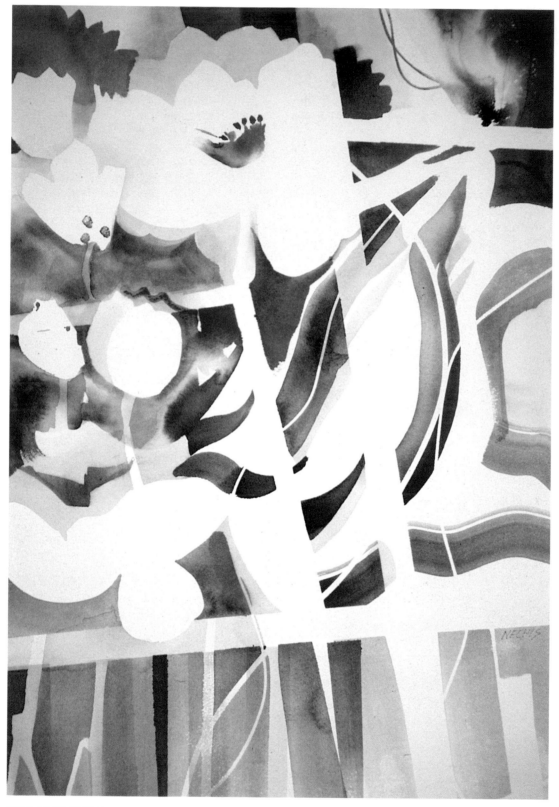

BOX OF FLOWERS
22 × 15" (55.9 × 38.1 cm). Collection of the artist.

I used narrow charting tape as well as artist's masking tape for the initial white lines. The horizontal block across the bottom containing stem shapes helps to expand the paper visually, thus alleviating the design problem of the narrow vertical format. The last step was the addition of pale pink washes to soften the contrast of the white strips.

This view of Vermont inspired my painting, *New England Autumn*.

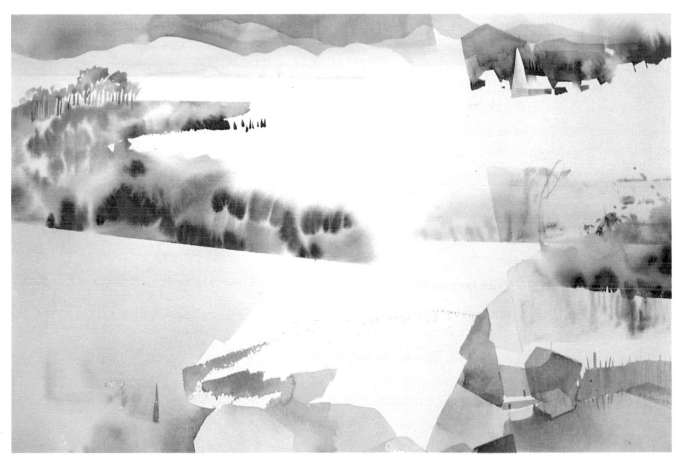

NEW ENGLAND AUTUMN
15 x 22" (38.1 x 55.9 cm). Collection of the artist.

I started this on location in Vermont. Initially, some of the taped divisions were too noticeable, so from time to time I added paint to some of them. I recently added the soft graded wash at the bottom left by rewetting into the area of the brightly colored trees, avoiding a telltale sign of where I stopped. I reversed common rules and made the foreground cooler and less detailed, the distance warmer and more detailed.

Playing with Shapes

My experiments with tape led me to a series of works in which I incorporated the subject matter with taped areas that described the hard edges of window frames, fences, porch railings, girders, and abstract forms.

Although I still occasionally use tape to indicate sections, and love experimenting with it, I have recently been challenged by finding new ways of using space. My predisposition to discard any mechanical means of picture making in favor of relying on my creative process has led me to three new ways of sectioning paper: with abstract geometric shapes, with the shapes of the subject matter, and with shapes superimposed on traditional work.

I now use a pencil to indicate the divisions. Sometimes I make geometric shapes and sometimes free-form shapes. They can be nonobjective, or shapes of subject matter, or a combination of both. I can prevent design flaws by placing cut-out paper shapes into positions which simulate the design before I paint it. I remain inclined to make changes as I proceed, rather than to plan first, but I do recommend planning to anyone who cannot quickly change course.

I usually begin by developing the area of major interest. I then dry it and paint an abutting section. The first section tells me what the second needs. If I do not vary the values where the edges adjoin, I will lose the shape; if I vary them too much, both shapes will be isolated from each other.

Marylyn Dintenfass
PARADIGM SERIES: HE DID IT.
Ceramic, graphite, and steel on plywood, 22 × 22 × 7" (55.9 × 55.9 × 17.8 cm). Collection of the artist.

An exquisite artist, Dintenfass is a close friend whose work and temperament are vastly different from my own. Our ideas and commitment parallel each other's, and she has exerted an influence upon my work.

You can map out a painting first by playing with cut-paper shapes. I overlap them to create depth or a resemblance to collage. If edges of shapes abut, you then have the same problem as when you line up a tree trunk with the edge of a house.

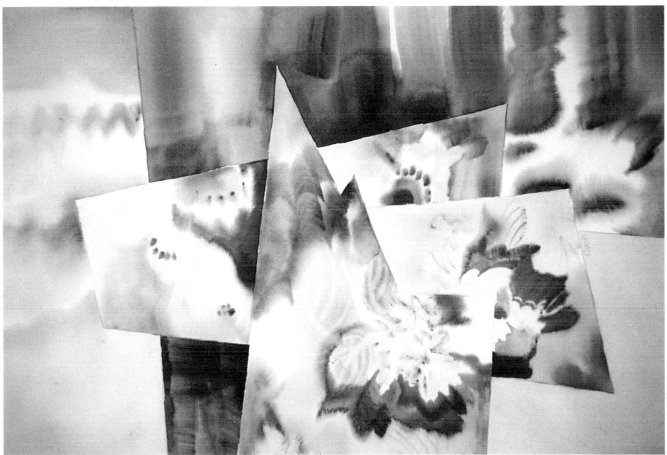

CHAPEL IN THE WOODS
15 x 22" (38.1 x 55.9 cm). Collection of the artist.

I first drew arbitrary geometric shapes to challenge me. The piercing shape resembled a steeple, and I took care to retain this shape. I added a feeling of woods behind. I signed it along the diagonal at the right, so that it may be hung two ways—a new rhythm can be found when the painting is turned upside-down. The color change from warmer on the right to cooler on the left was deliberate to avoid monotony. The interiors of the sections are predominantly wet-into-wet to add contrast to the hard-edged frame around each.

EARTHQUAKE
15 x 22" (38.1 x 55.9 cm).
Collection of the artist.

As in *Chapel in the Woods*, the shapes
suggested content. I deliberately misaligned
the glazed edges on the right to depict a fault
line. I painted the lower-left section last,
determined not to play it safe at the end of a
successful process. My boldness almost
destroyed the painting. Though I had
emphasized the white abstract tree with a
garish staining color, I was able to wash out
some of it and neutralize the green with an
orange glaze.

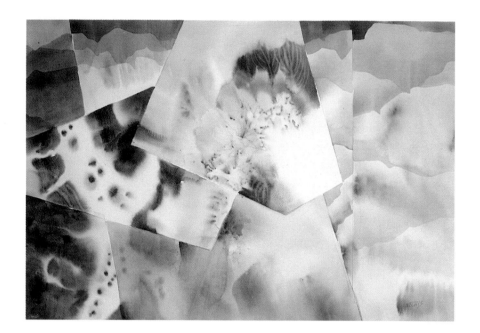

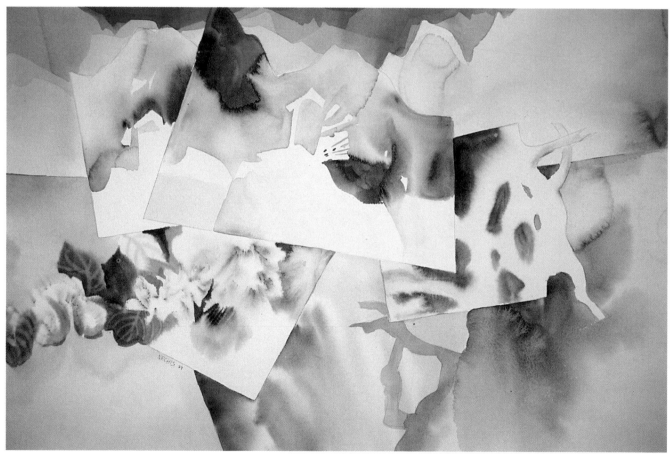

JASPER
15 x 22" (38.1 x 55.9 cm). Collection of the artist.

I depicted subject matter as I drew each section. My environment, the Canadian Rockies,
imposed itself, and my trees echo the forms of some of the animals I had glimpsed.

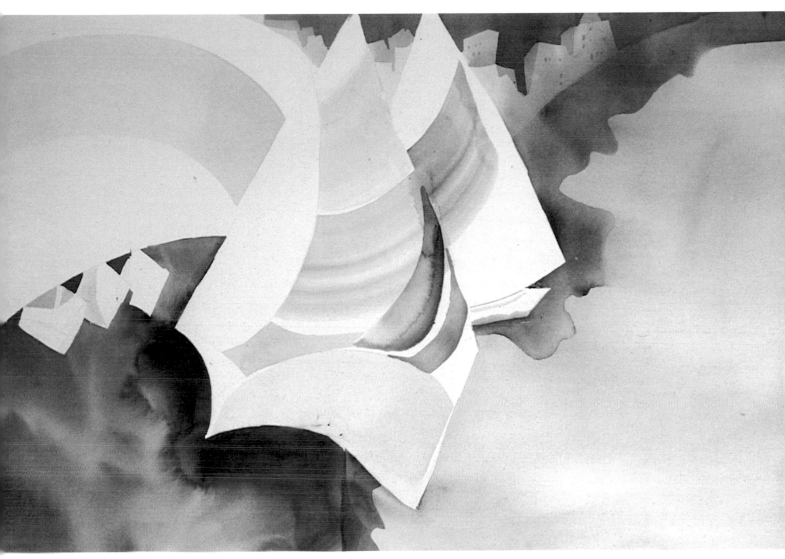

SAILBOAT SECTIONS
15 x 22" (38.1 x 55.9 cm). Collection of the artist.

The blue water of Florida influenced my work on this abstract painting,
and the theme emerged.

Improving Design in Traditional Work

I discovered another method of working with a grid largely by accident. I was giving a painting demonstration after dark, in a lighted outdoor space in a lovely alpine environment. I became intimidated by my surroundings and unwisely chose to paint the first image in my line of vision. I chose a vertical format and painted a large tree surrounded by several rocks at its base. I was instantly in trouble. The tree I painted was angular in shape, the rocks curved, and there was no predominant pattern to link them. The shape of my paper did not remotely support where I placed the initial shapes. Being in trouble, I threw caution to the winds and seized upon a radical experiment: I picked up a strip of matboard and using its straight edge as a guide, I arbitrarily drew angled horizontal lines across the paper. Then I glazed between these lines, using varied values and superimposing a consistently angular theme. *Idyllwild* was the result.

I have long known that the worst way to achieve success is to try to succeed, but I learn slowly. Several months later, I was invited to teach a workshop with a group of well-known painters. My goal was to paint a successful painting, because the outstanding artist Rex Brandt was watching my demonstration. It is much more effective for me to paint to see what I may find. Still, I had been getting quite successful at drawing trees with water, so I began in this vein.

Before long, the painting became too repetitious, and I was feeling desperate. I was painting near the shore and introduced some sailboats—not a wise decision, for they were irrelevant to my subject. Finally, choosing my *Idyllwild* solution, I superimposed and glazed angled forms to tie the incongruous shapes together.

I was delighted to find this way to rescue a failing painting. It is also a relief to know that this solution will serve me well if I get into similar trouble again.

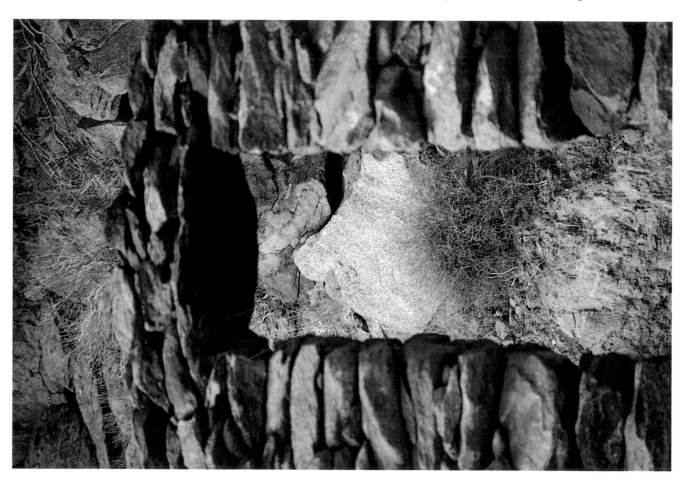

Turned sideways, my photograph of a stone doorway shows the world around us to be filled with images in sections. You can train your eye to find them everywhere.

IDYLLWILD
22 x 15" (55.9 x 38.1 cm). Collection of the artist.

Although it was not consciously intended, the dark and light contrasting shapes across the center suggest water and reflections.

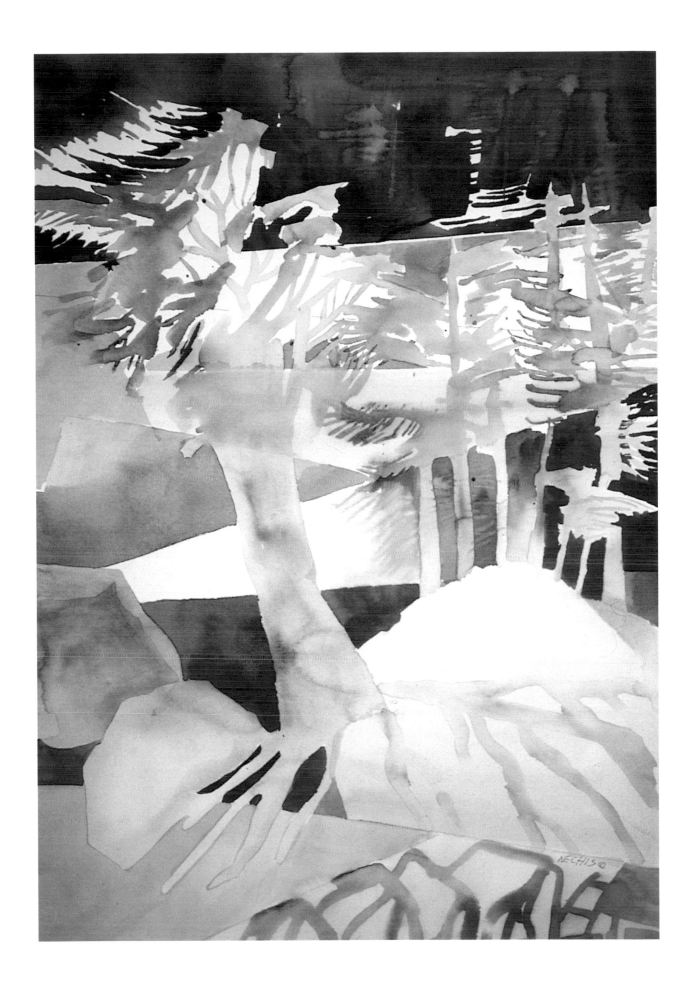

USING THE NATURAL ENVIRONMENT

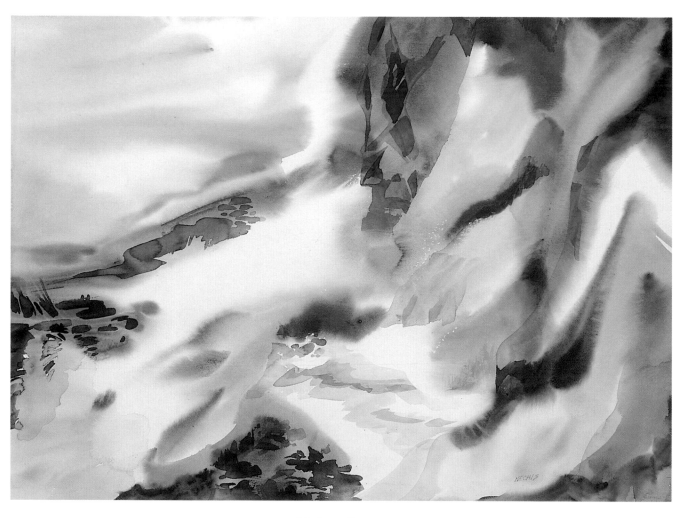

NA PALI COAST
22 x 30" (55.6 x 76.2 cm). Collection of the artist.

I HAVE OFTEN PAINTED what I thought was an abstraction, only to find similar shapes in nature afterward. A student sent me some photographs of flowers, calling them "Nature Imitating Barbara Nechis." We imitate nature, and then it seems as if, in return, nature imitates us. ❦ Sometimes paintings evoke questions, and nature answers them; sometimes paintings tell us more about nature than nature does itself. When a painter is an observer of nature, he or she can synthesize the information nature provides and present it in a form that makes us see, and sometimes wonder. ❦ What an artist really observes in nature is pattern, not objects. If we are not aware, we end up painting objects, not the patterns. To allow too many objects to invade and interfere with our vision deprives our paintings of their function of reporting our true reactions to nature, of communicating something of its essence. ❦ I actively engage in making the natural environment become a part of my paintings, by spending time in the woods, in the mountains, and at the seashore. Letting my thoughts run free, listening to music, and being with friends are part of this engagement as well. Being an artist is far more than working daily in one's studio. ❦ I took two walks with friends, the first along a wooded trail. My friend's energy delighted me as she whipped along the trail, but she missed the root patterns, the hidden mushrooms, the mosses, and the rock treasures that filled my pockets. Another time, as I walked with friends along a secluded beach, they talked of many things, while I absorbed the tidal shapes, sand textures, and cottage rooftops emerging from dunes in the distance—gathering up the shapes and the spirit of my work.

If you can combine realism and abstraction, you've got something terrific.

—ANDREW WYETH

8 PERCEIVING AND EVOKING NATURE

I'm a moon watcher and I wade in tide pools.

—REUBEN TAM

Reuben Tam's picture *The Laver Tide* and Frank Webb's *Sunflowers on a Flat Field* are examples of work that is, for me, strongly evocative of nature.

I first met Reuben Tam when I was a young painter and he was teaching at the Brooklyn Museum. He had a summer studio on Monhegan Island, Maine, which I once visited. Viewing his work, I was struck by his ability to evoke the feeling of his environment through paintings that were quite abstract. He rendered the natural landscape more spiritually and with less constriction than the work of others who had painted the same subjects.

I visited him again when he had retired to Kauai, in the Hawaiian Islands. Much of his work was of the sea. One picture spoke to me of the structure of waves better than my own perceptions over many summers at the seashore. I had never observed that the leading edge of a wave could have a shelf-like shape and depth.

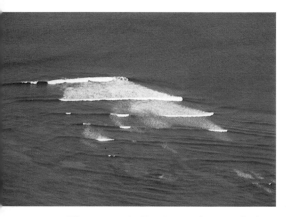

These waves in Kauai were photographed from a vantage point similar to the view from Reuben Tam's studio.

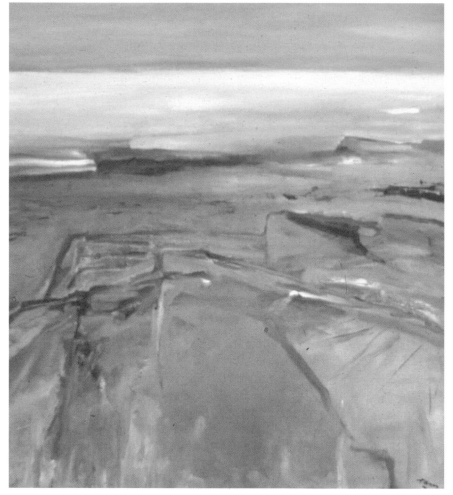

Reuben Tam
THE LAVER TIDE
Acrylic on canvas, 24 x 22" (61 x 55.9 cm). Collection of Nancy J. Budd, Kauai, Hawaii.

I had never noticed shelf-like waves before, but Tam's perception of nature, as conveyed through his picture, has heightened my own.

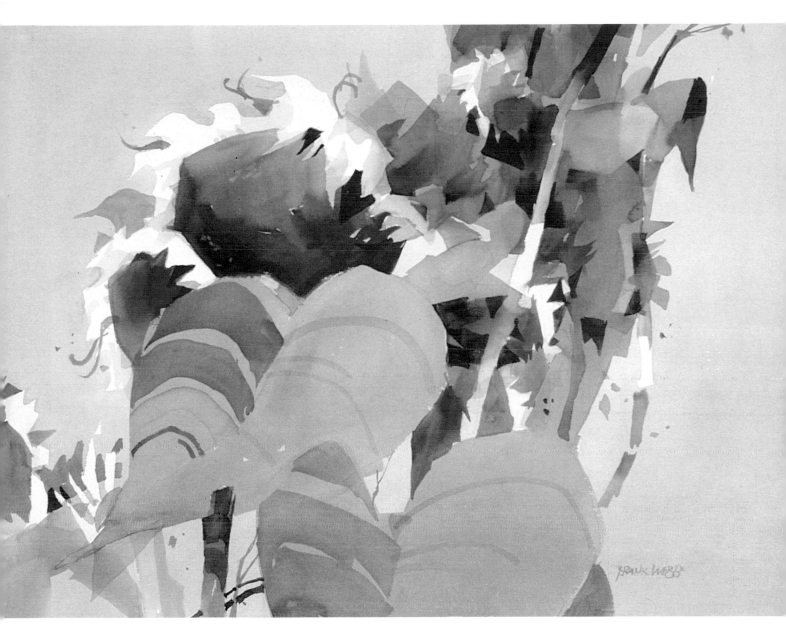

Frank Webb
SUNFLOWERS ON A FLAT FIELD
Watercolor on paper, 22 × 30" (38.1 × 76.2 cm).
Collection of Barbara Nechis.

I look at this painting daily, often seeing only shapes and patterns. Compare my photograph with this painting. The photograph of sunflowers from my garden shows how real Webb's flowers are, though they are certainly not the face-forward cliché version we usually see of sunflowers. Webb evoked something of the essence of his subject.

This is a beached, weathered boat many of my students chose to paint. For this photo, I went in close to capture nature's influence. I achieved an ambiguity of subject and an emphasis on shape that I prefer to the boat itself.

Looking for the essence of nature: here selectivity in the same landscape delivers an abstract image.

Photographed on a glacier, the layers of light in the ice were, to me, the most spectacular content among many more panoramic glacial scenes.

The composition of water surface and underwater rock allows the mountains to appear in the reflection.

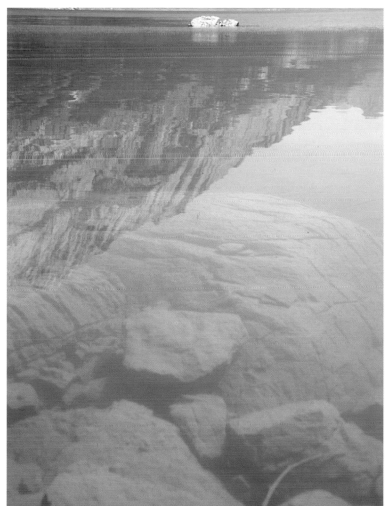

A split-second moment; this beach will not look this way again. I hope to use the shape of wet sand, resembling a shadow, in a future painting.

Absorbing the Environment

Immersion in a region can broaden rather than narrow the scope of what one has to say. Regionalists are specialists of their microcosms. No one doubts what the countryside looks like in Andrew Wyeth's part of the world. He says he finds new subject matter to be boring. Van Gogh and Provence are synonymous to me. Georgia O'Keeffe was able to make us feel the essence of the skylines of New York and the mountains of New Mexico because she knew her subjects intimately.

When we approach a new environment, it is tempting to set to work painting. Sometimes our impatience can be time-consuming. The faster one begins to paint, the more often it can result in failure. One needs time to notice what images are truly representative of a place and to choose, discard, feel comfortable.

Conceive of the environment as being a shy child: approach it gradually. Be tentative, let the place seep in. Put your toe in the water, then slowly wade in.

CASCADE
12 x 18" (30.5 x 45.7 cm). Collection of the artist.

A piece of nature abstracted.

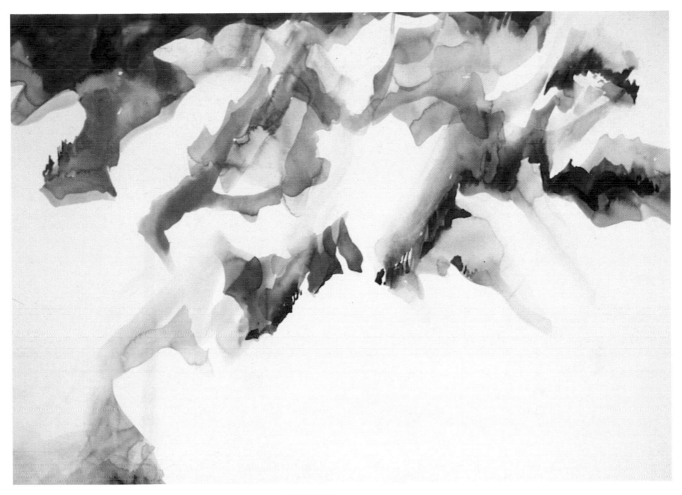

DENALI DUSK

22 x 30" (55.9 x 76.2 cm). Watercolor on # 80 cold-pressed Bainbridge board. Collection of the artist.

Although the colors of snow are cool, I needed the addition of red to convey my excitement in finding myself in such an awe-inspiring environment.

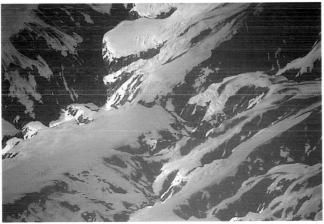

This aerial photo, full of abstract qualities, was taken over Mt. McKinley National Park .

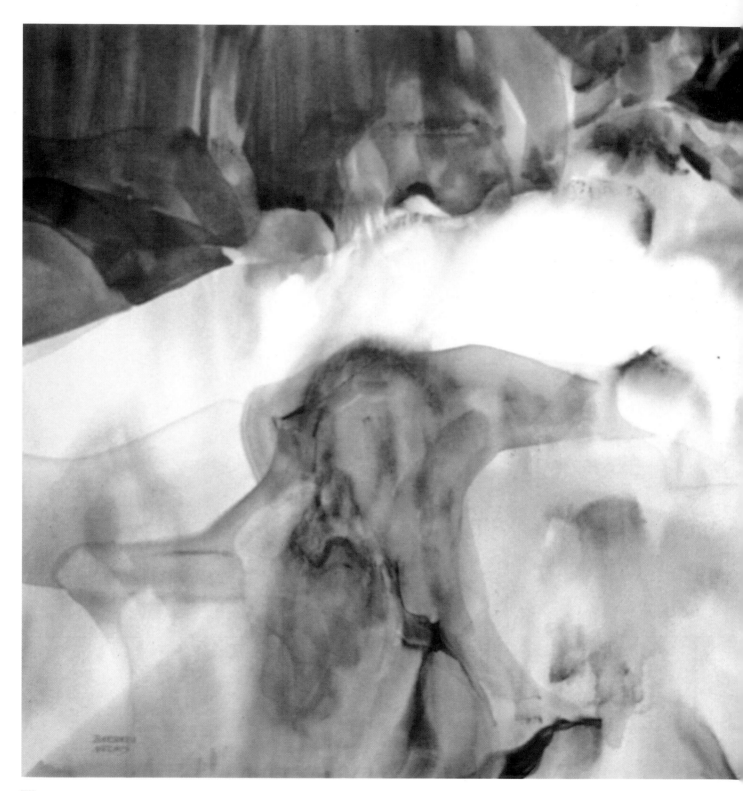

WILDCLIFFE
22 x 30" (55.9 x 76.2 cm). Collection of the artist.

The largest shape, which was painted last, is a positive glaze layer that lets us see
other colors, values, and shapes beneath it. This transparency can help to convey
an atmosphere of mystery.

In Soldotna
22 x 30" (55.9 x 76.2 cm). Collection of Meredith Sabini, Ross, California.

Thoughts of glaciers and crevices and my experience of Alaska impelled this painting. The final layer, drawn with water and infused with red pigment, was the ribbon that tied it together.

Painting on Location

Though I am an observer of nature, I am a studio painter by preference. Most painters know that access to clean water, clean paper, and a clean palette promotes thoughtful work. For me, these are better obtained indoors. My outdoor work is frustrating, for I know that an edge is better controlled and the table sturdier indoors. The option of working outdoors is rarely available to most artists. Printmakers, weavers, muralists, and those who live in northern climates or big cities may never consider working on location as an option, yet there is a mystique about plein-air painting.

I insist on periodic trips to the coasts, mountains, deserts, and glaciers, because I know these exposures alter my point of view. In the cocoon of my studio, my thoughts flow without renewed perceptions.

By now I have learned deliberately not to paint my first choice of a subject in a new environment. I take my time before starting. What I seek is the rhythm of a place, its patterns of repetition. Opposite approaches often work. For example, many repetitious strokes can add up to a single shape. On the other hand, a simple shape of a few

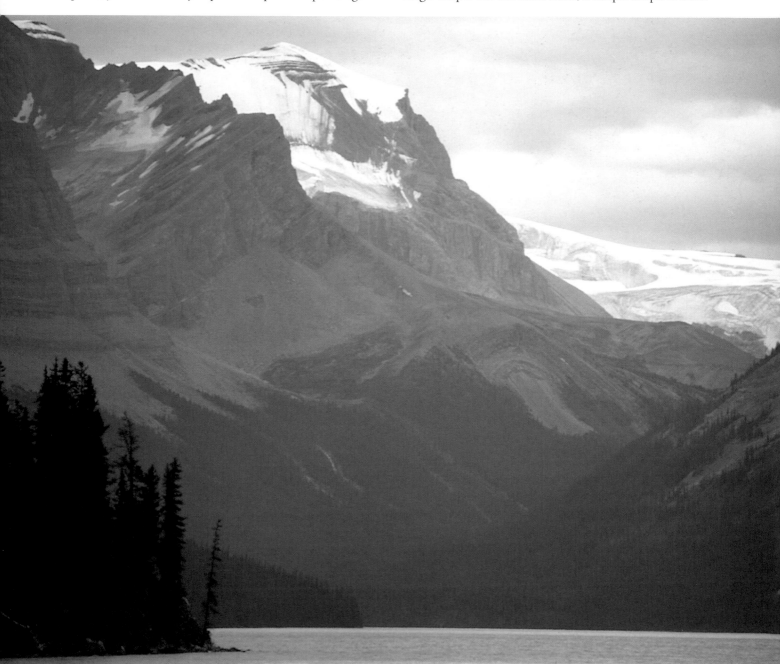

This is a grand scene I photographed and painted at Maligne Lake, in Alberta, Canada.

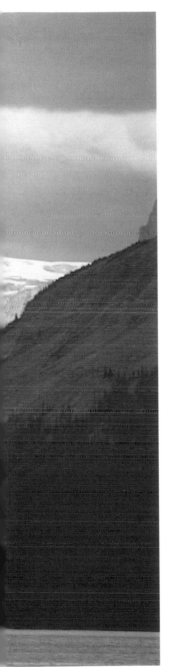

strokes, but with definition at its edge, can have a similar effect. Think of painting trees, fences, and any other repetitious shape as you would paint hair. How many individual hairs would you paint? How much would you suggest mass? Describe the edge as real, the inner as mass.

Another bit of essential advice: No matter how costly the trip was, no matter how much visual pleasure you derived from an experience, you don't have to paint a subject unless you really want to paint it. It is permissible to visit the Grand Canyon without painting it.

Some of the places I have loved I have had no desire to paint at one time; later I reacted to the same experience entirely differently. After several trips to the Napa Valley, I was convinced I could live happily ever after in this beautiful place, but I had absolutely no desire to paint it. On a trip with students to Montepulciano, Italy, after too much sightseeing and not enough time to check my inner landscape, I stole a glorious few hours to paint by myself. In the resulting diptych (see pages 124 and 125) I can also easily see a reflection of the Napa Valley!

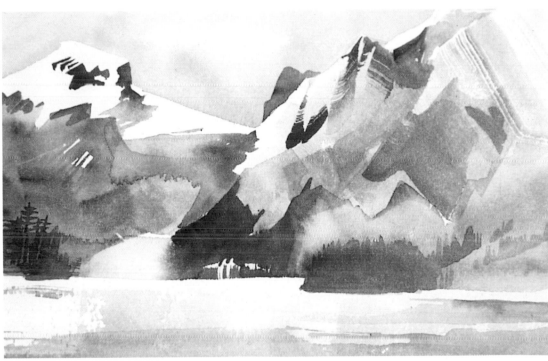

FROM SPIRIT ISLAND
Location sketch, 9 x 12" (22.9 x 30.5 cm). Collection of Pat Crowley, Jasper, Alberta.

I departed from my usual procedure and used the shapes of the mountains before me, as well as the colors of the cloudy day. Although generally I would put the mountains where I want them, rather than painting them where they appear, here I was more true to nature. But I asserted my personality in simplifying the textures and shapes.

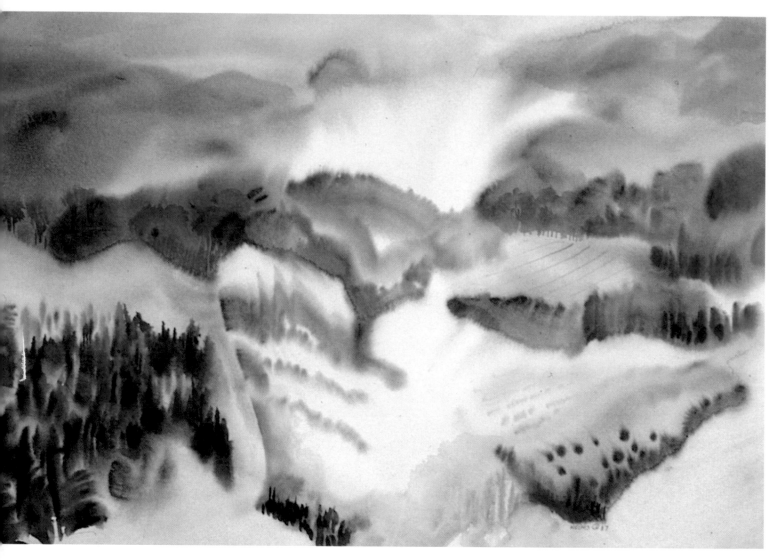

MONTEPULCIANO–NAPA
Diptych: Each panel 15 x 22" (38.1 x 55.9 cm). Collection of the artist.

The resemblance between Montepulciano, in the hills of Tuscany, and my home environment, the Napa Valley, is so strong I have mislabeled photos of the two— hence, the title. Both of these panels were done in Italy.

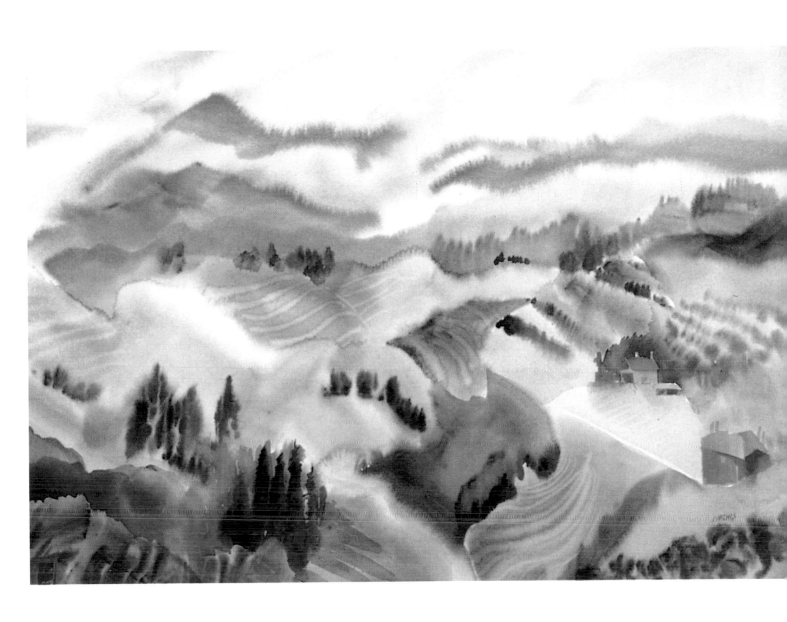

On a visit to France, I painted an unstructured underpainting with no thought of what it might become. On the following day, I took it along to the local market, shown here. It provided the rainy-day atmosphere, assertively so, for *Market Day in St. Rémy.*

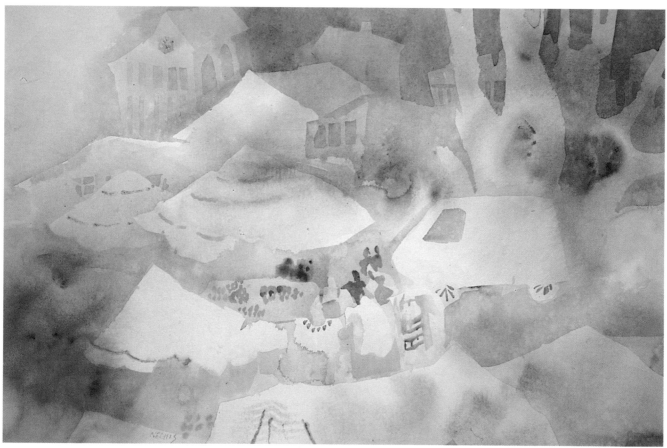

MARKET DAY IN ST. RÉMY
15 x 22" (38.1 x 55.9 cm). Collection of the artist.

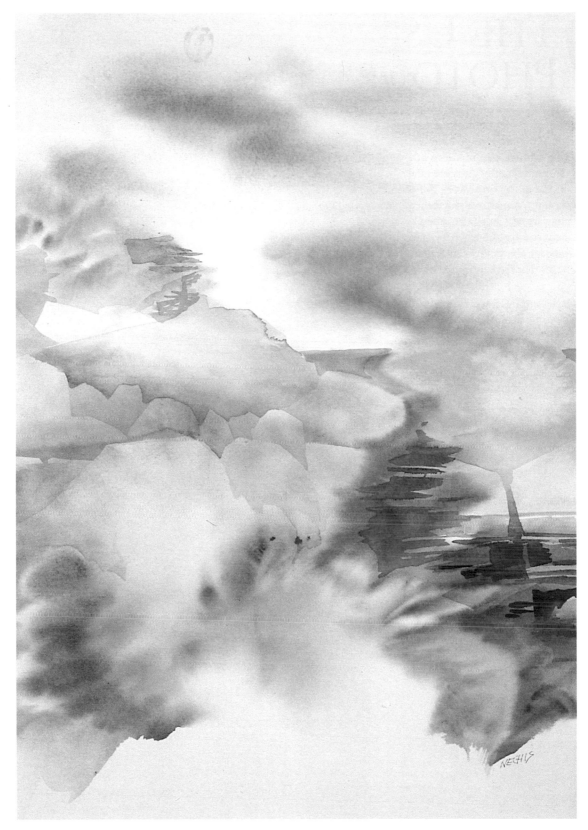

AND THE CLOUD CRIED
22 x 15" (55.9 x 38.1 cm). Collection of Thea and Richard Benenson, New York, New York.

A cloud slips out of the sky into the water as I let it break through my horizon line. I did this
just for the fun of it.

Photography for Reference

I rarely, if ever, paint directly from photos. I use the camera as an aid to implanting a vision and exercising my design skills. Many of the photos I take would be appropriate to use as a plan for a painting. My choice *not* to look at them as I work comes from my need to invent new images during the process.

When I first began to paint, I collected clippings, postcards, and photos, filed them according to subject matter, and referred to them to start or finish paintings. Only by allowing myself to refer to them for a limited time during the painting process did I avoid the temptation to copy someone else's viewpoint. Even an unintentional use of material can make a painting too derivative of its source, so I have preferred to use my own photographs as my sources.

However, if the material of others intrigues you, use it as a springboard. Begin your tree or waterfall, and when you get stuck, use a clipping for an idea of how to finish it. Or start from a photo and use it for a few minutes to suggest a subject or shape. Then put it away and let your painting take on a life of its own. Use the color from one photo, combined with the subject of a second and the value pattern of a third. A clipping turned upside down can inspire new ideas.

If I take the time required to make a drawing of the images I will need as reference material later, I will lose much of the experience that I seek in a location. By giving up the idea of pencil sketching, I have become free to enjoy and absorb; I no longer feel torn between experiencing and painting. Instead, I spend enough time in a place to absorb its essence. Visiting people, dining, exploring, and focusing my camera hundreds of times, whether or not I click the shutter—all these contribute.

Sketching is about seeing and putting what you choose to record on paper. When you sketch, your attention is divided between your subject and the paper. Using your camera, there is no distraction from eye to hand. You concentrate, frame, and click without interruption.

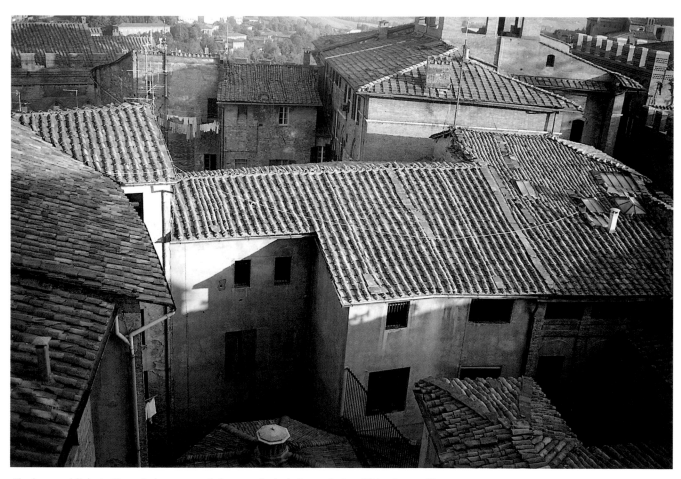

Shadows and light in Siena, Italy, suggested shapes to include in a painting. This photo will serve as a handy reference some day.

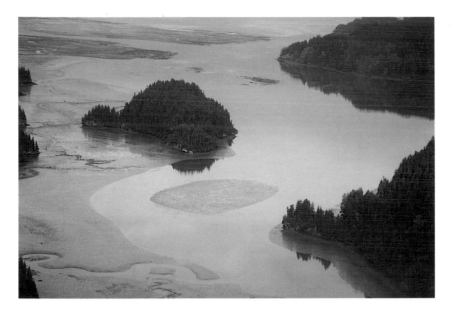

Above Halibut Cove, in Homer, Alaska, what interested me is the film of ice separating the island from its reflection. I expect this detail to find its way into a future painting.

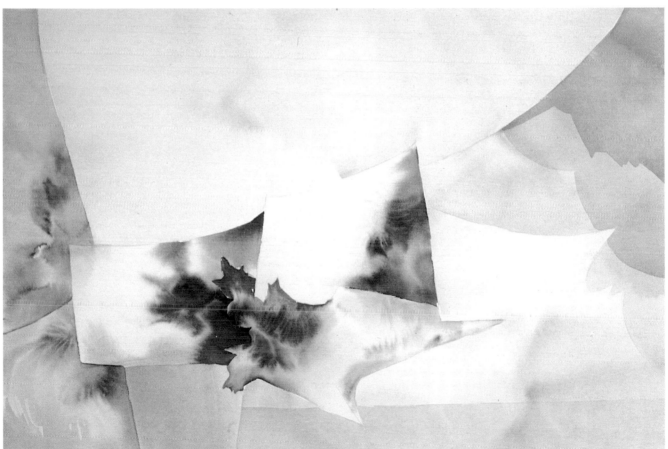

SHAPES IN SPACE
15 x 22" (38.1 x 55.9 cm). Collection of the artist.

Just as the reflections emerge from the ice edge in my Halibut Cove photo, my wet-into-wet strokes leak from behind the hard edges in this sectioned painting.

Photography as a Design Tool

There is a unity of shape both in aerial views, which gather distances together, and in closeups, which eliminate everything extraneous. When one is in the woods, the surrounding trees are dominantly vertical. From the sky, the dominance is a blending of the treetops. It is more difficult to find such a harmony when choosing subjects from the middle ground.

From the air, there are fewer distractions of detail. It is easy to see that the topography of a region has unity. A mountain range appears one way, farmland another. When the two abut, if I want both images in my painting I generally decide which of the pieces will be dominant, then select more of that one than the other.

Zooming in for a closeup is creative cropping. It cuts out all inessentials. In a closeup, texture can unify form. A log, the side of a barn, or a strip of beach—each will have its own rhythm of texture imprinted throughout.

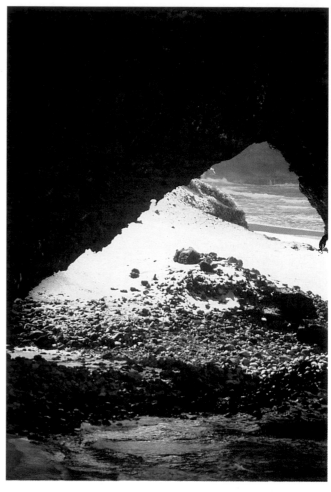

On Kauai, in the Hawaiian Islands, nature shows its flair for strong design. The pilot Jack Harter showed me this "see-through."

I framed these two Mexican women so that the geometrical shapes of red, white, and black clothing on the left balance the navy-blue sweater shape on the right.

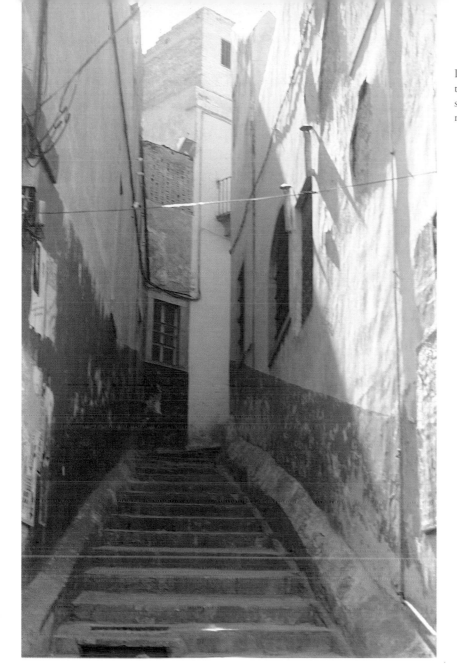

In Guanajuato, Mexico, the repetition of triangular shadows and painted shapes suggests a patterned painting employing many overlapping glazes.

Large rusting pipes suggest a painting design that departs from the usual. I would place something of special interest in the area of the "telescope" pipe.

If you find a rhythm, the design will take care of itself.

My framing emphasizes the composition here. I obtained variety in the two types of snowy patterns: the top portion is light against dark, the bottom is midtone against light.

At Les Baux, in Provence, I emphasized positive and negative with light square against dark, and dark square against light.

Another positive and negative emphasis with the midtone rock against both light and dark balanced by the dark hole in the white snow.

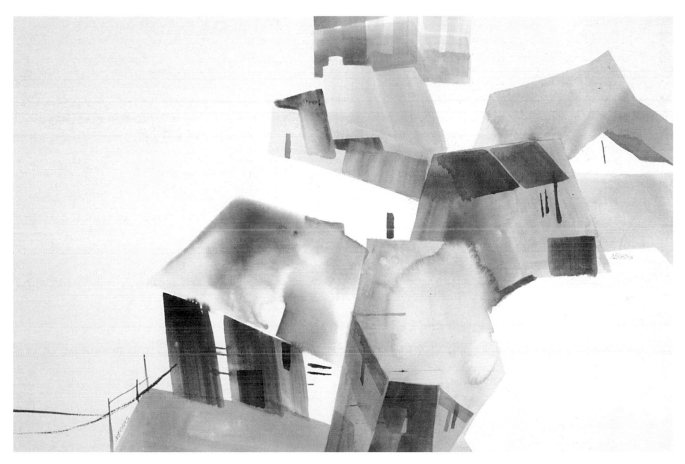

YIN AND YANG
15 x 22" (38.1 x 55.9 cm). Collection of the artist.

I enjoy finding dark values and light values in interpenetrating relationships, as this painting and these photographs show. Here, the most interesting detail is the courtyard shape in the middle, with a chimney silhouetted against it. Or is it a doorway in a wall?

I call this *Baubles at Bartlett's Cove.* Circles, shadows, and the parallel diagonal layers, starting at the upper right corner, unify this photo.

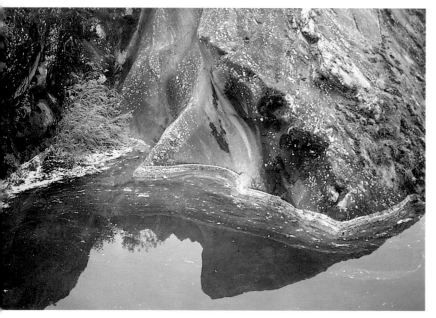

Nature repeats its curves and triangles. I was interested, too, in the "off-register" reflected shapes.

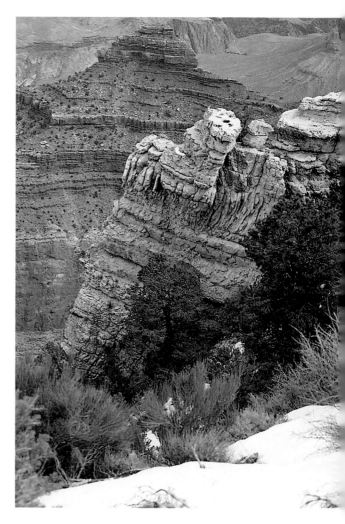

Four layers, from foreground to background, introduce great depth even though this is a relatively close-up canyon view.

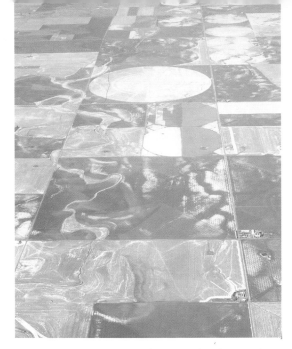

From the air, rectangles are familiar sights, huge circles a little less so—unless you are over the Midwest, where I shot this irrigation pattern.

Angles and color enhance the repetition in farmland patterns.

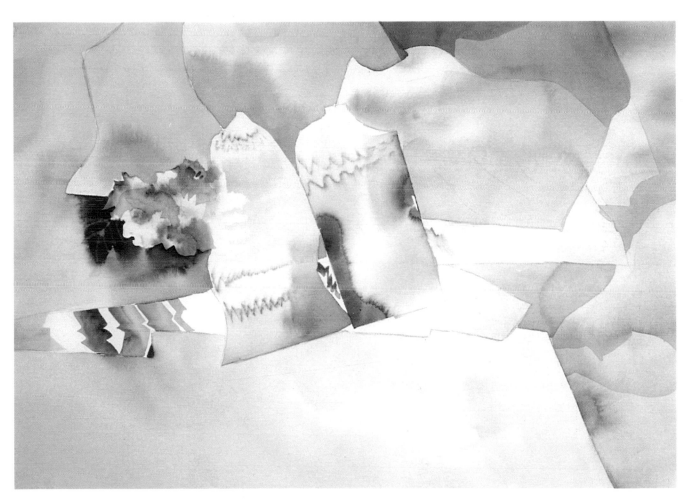

SPACE QUILT
15 x 22" (38.1 x 55.9 cm). Collection of the artist.

Painting an airy-looking abstract, I think of how distance ties together the shapes in aerial photographs. Even with its bold highlights, this painting has a similar unity.

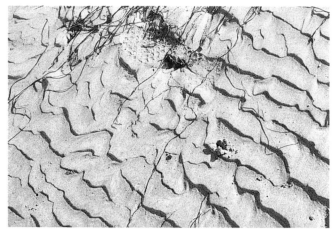

This picture designed itself. The sand ripples would be useful in depicting a shingle roof.

The rhythm of this ruin in Mitla, Mexico, is enhanced by shadow shapes.

At the Air Force Academy chapel, it was hard for me to resist photographing patterns.

Photography as an Art Form

When I make a photograph, rarely do I click the shutter expecting to produce a masterpiece. But if the subject and form are interesting to me, I anticipate the possibility of a great result.

My favorite photos and paintings are equally the result of perseverance, thoughtful design, creative ingenuity, and luck. The inner process of photography is different from painting. I design and plan when I sight through the viewfinder. The decisive moment is when I release the shutter. When I look through the lens, it is usually my intention to make an original photograph, but only a small percentage of the shots end up reflecting the personal statement I seek.

I'm not really cut out to be a photographer. Once when walking a beach I found an interesting rock which had a white line on it. The surf repeatedly made two foamy lines that converged on it, leaving a crossed white line. I knew that if I focused on it for only a few moments I probably would get a good shot. But I didn't have the patience!

Unfortunately, it is quite easy to be taken by something beautiful and to photograph a cliché. It happens to me all the time. Sometimes it is simply a way of getting the obvious out of my system so that I can proceed to the heart of what I'm looking for. If you are aware that you have photographed a cliché, then you don't have to waste your time painting it.

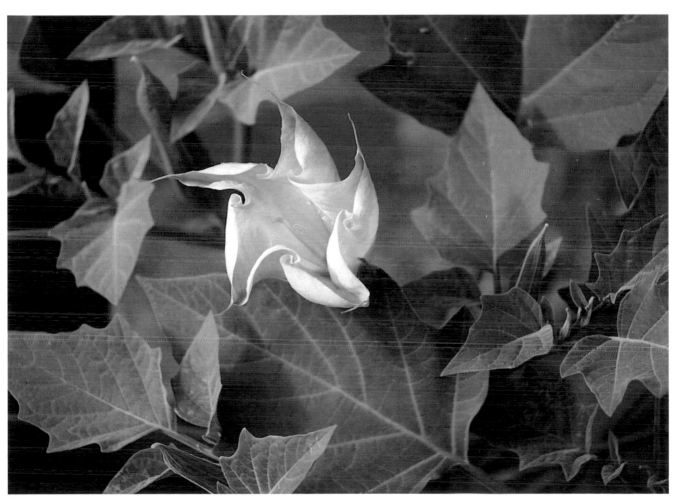

When extraneous shapes are left out, good design imposes itself.

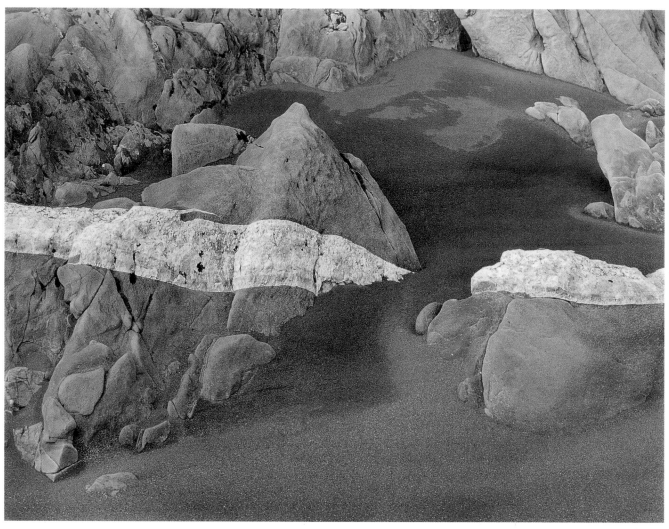

Gary Freeburg
QUARTZ INTRUSION,
WEST CHICHAGOF ISLAND, ALASKA.
Toned silver print. Collection of Barbara Nechis.

This photograph says to me what I hope my paintings say to others; it is the artist's personal interpretation of nature.

Gary Freeburg's work influenced me here; I don't claim originality. Although I like the space division, consciously planned, I should have made better use of the parallel vertical lines; they serve no purpose in the design.

Warm and cool alternate in some of nature's most beautiful patterns.

I grabbed my camera and got lucky once when the frosty vines of our vineyard had a ghostly look.

BIBLIOGRAPHY

Burchfield, Charles, *Charles Burchfield's Journals: The Poetry of Place,* edited by J. Benjamin Townsend, State University of New York Press, 1992. (Quote from September 26, 1914.)

Carmean, E. A., Jr., *Helen Frankenthaler: A Painting Retrospective,* Harry N. Abrams, Inc., New York, 1989.

Cooper, Douglas, *The Cubist Epoch,* Phaidon Press Ltd., London, 1971.

Cowart, Jack, Sarah Greenough, and Juan Hamilton, Georgia O'Keeffe: Arts and Letters, New York Graphic Society, 1987.

Crispo, Andrew, *Ten Americans: Masters of Watercolor,* Crispo Gallery, New York, 1974. Quote by John Marin.

Fritz, Robert, *The Path of Least Resistance,* DMA, Inc., Salem, Mass, 1983. Picasso quoted p. 67, Kandinsky p. 126, Beal p. 53.

Gladstone, Valerie, "Helen Frankenthaler's Intimate Abstractions," *United* (an In-Flight Publications magazine), March 1985.

Haskell, Barbara, *Milton Avery,* Whitney Museum of American Art, in association with Harper and Row, New York, 1982.

Haskell, Barbara, *Charles Demuth,* Whitney Museum of American Art, in association with Harry N. Abrams, Inc., New York, 1987.

Kafka, Franz, "Before the Law," *The Basic Kafka,* Simon and Schuster, Inc., New York, 1946

Kandinsky, Wassily, *Concerning the Spiritual in Art,* translated by M.T.H. Sadler, Dover Publications, New York, 1977.

Lao Tzu, *Tao Teh Ching,* translated by John C. H. Wu, St. John's University Press, New York, 1961.

Lyons, Nathan, *Photographers on Photography,* Prentice-Hall, Inc., Englewood Cliffs, N.J., 1966.

McPhee, John, "A Roomful of Hovings," *A John McPhee Reader,* Random House, New York, 1976.

Museum of Modern Art, "The Modern Star," published for the Museum's show Andy Warhol: A Retrospective Exhibition, New York (Feb. 6—May 2, 1989).

Phillips, Marjorie, *Duncan Phillips and His Collection,* Little, Brown and Co., Boston, 1970. (Quote from p. 288).

Saint-Exupery, Antoine de, *The Little Prince,* translated from the French by Katherine Woods, Harcourt Brace Jovanovich, Inc., New York, 1943.

Schneider, Pierre, *Matisse,* Rizzoli, New York, 1984.

Schwartzman, Myron, *Romare Beardon: His Life and Art,* Harry N. Abrams, Inc., New York, 1990.

van der Post, Laurens, *Jung and the Story of Our Time,* Pantheon, New York, 1975.

van Gogh, Vincent, *Dear Theo: The Autobiography of Vincent van Gogh,* ed. Irving Stone, Doubleday, New York, 1937.

Waldman, Diane, *Mark Rothko: A Retrospective, 1903–1970,* The Solomon R. Guggenheim Foundation, in association with Harry N. Abrams, Inc., New York, 1978.

Wyeth, Andrew, quoted in *Time,* December 27, 1963.

INDEX